C000000609

GREAT RAILWAY JOURNEYS

THE CHILTERN LINE TO BIRMINGHAM

ROGER MASON

AMBERLEY

First published 2018

Amberley Publishing
The Hill, Stroud
Gloucestershire, GL5 4EP

www.amberley-books.com

British Library Cataloguing in Publication Data.
A catalogue record for this book is available from the British Library.

ISBN: 978 1 4456 6836 9 (print)
ISBN: 978 1 4456 6837 6 (ebook)

Origination by Amberley Publishing.
Printed in the UK.

Preface

I acquired a love of trains at a very early age and I probably have my father to thank for it. He knew the stationmaster at Princes Risborough and persuaded him to let me have an enormous railway poster advertising the Cornish Riviera Express. It was installed in my bedroom and each morning it was the first thing that I saw when I woke up. In this book's High Wycombe chapter I tell the story of me taking an unauthorised steam train footplate ride at the age of seven.

Like many small boys I had an Ian Allan trainspotting guide, and I collected engine numbers for the line passing through Aylesbury, where I lived. My friend and I got all the numbers except one, which we reckoned must be out of service. Then his mother saw it and he ticked it in his book. I was outraged at this monstrous behaviour and I still feel the same way. Another memory is watching the decorated special trains bringing supporters to the FA Cup Final at Wembley. I believe that it was Blackpool *v*. Bolton in 1953.

This love of trains led me to write *London to Birmingham by Rail*, which was published in 2013. It was based on the line from Euston Station in London to New Street Station in Birmingham, and I followed it with *London to Sheffield*, which was published in 2016. Neither of them were technical books about railways, but described fascinating things that could be seen from the windows of trains making the journeys. This book is the third in the series and is written in the same way.

I visited all of the sites described, some of them more than once, plus some others that were not suitable for inclusion. I photographed three red kites circling together, but the quality of the result was not good enough for inclusion, so I used another picture. This is the only photograph in the book not taken by myself or my family. I must thank my wife, Dorothy, for the one of me at Bicester Village, my granddaughter Hannah for the one of Hatton Locks and my granddaughter Lauren for St Mary's Church in Warwick. I did the rest. I have explained to my granddaughters that they will only share the royalties if the book sells an exceptional number of copies. While expressing my thanks it would be remiss not to mention my wife's cousin, Geoff Wright. He read every chapter and I acted on many of his suggestions.

This is my twenty-fifth book and I have greatly enjoyed writing it. I hope that it shows and I hope that you enjoy reading it.

Roger Mason

Contents

Marylebone Station

Marylebone must be an important station; it is, after all, one of the four London termini featured on the board of the ever-popular game Monopoly. Chiltern Railways, the company that runs the services and the station, is proud of this, and in both the men's and women's toilets a complete wall is given to a reproduction of the Monopoly board. An arrow points to the station's position on it, and the word 'HERE' is written underneath the arrow. The doors of the toilet cubicles feature the pieces (top hat, car etc.) that are used in the game. During my visit I formed the impression that the toilets were the cleanest and smartest that I had seen on any station – a very good start to the journey.

Marylebone, which is Grade II listed, is indeed important, but it is one of the smaller of London's railway termini and it was the last to be built. It is located on Melcombe Place, just north of Marylebone Road. It was opened in 1899, and at the time it linked London with the cities of Nottingham, Sheffield and Manchester. The Great Central Railway extended southwards through Aylesbury, and the link into London was the last part to be built. This necessitated the demolition of more than 500 houses and the relocation of more than 3,000 people.

Objections caused the construction of the station and the line into it to be delayed, the most serious of them being lodged by the Marylebone Cricket Club (MCC). This was because an approach tunnel just north of the Regent's Canal passes under Lord's Cricket Ground. The railway company started work on the tunnel shortly after the end of the 1896 season, and the ground was ready for the start of play in spring 1897. This was the promise and it was kept. The method of construction was cut-and-cover, and the spoil was taken away to Neasden. At the peak of the work, eighteen trains a day did this.

The station opened to coal traffic in 1898, and on 9 March 1899 750 invited guests enjoyed a six-course luncheon in a giant marquee erected on the concourse. Photographs appear to show that they were all men. Three specially decorated trains transported them to the station. A photograph taken shortly after the arrival of one train shows that all the men on the platform were wearing hats, which was the universal practice at the time. There were no cold heads in 1899. The first commercial passenger train ran into the station six days later. A wharf on the nearby Regent's Canal permitted the transhipment of coal and other merchandise.

The original plan was for the station to have eight platforms, but due to financial problems only four were built. The freight business was profitable, but the passenger side of the business struggled to compete with the routes out of St Pancras. A new line to High Wycombe was opened in 1906 and this comprises the first part of the journey from Marylebone to Birmingham that is detailed in this book. As part of the savage cuts to the railway system instigated by Dr Beeching in the 1960s, the original Great Central Line was closed north of Aylesbury in 1966. After this the station served routes just to Aylesbury and High Wycombe, with some services extended to Banbury.

In the 1980s the closure of Marylebone Station was seriously considered. Fortunately the plans to close it were thwarted, as the subsequent expansion in the demand for rail travel would have caused severe capacity problems.

In 1996, after rail privatisation, Chiltern Railways took over the station and routes. Marylebone was expanded in 2006, with the addition of two extra platforms, and there are currently six of them. It now despatches trains to Snow Hill Station and Moor Street Station in Birmingham.

There is no denying that the station has a certain charm and a relaxed atmosphere, certainly compared with London's Euston, Liverpool Street, King's Cross, Victoria and Waterloo. There are pleasing reminders of its late Victorian and Great Central Railway heritage. An attractive example is the original railings outside, which have 'GCR' (for Great Central Railway) incorporated into the design of the ironwork.

There are two plaques placed together in one of the walls of the concourse. One marks the station's centenary and it was unveiled by His Honour Edgar Ray QC. He was the son of Sir Sam Ray, who was the General Manager of the Great Central Railway from 1920 to 1922.

The other plaque is a tribute to the late poet laureate Sir John Betjeman. He engaged with the people more than any other British poet of the last seventy or so years, having had the common touch, and, what is more, he wrote poetry that rhymed. Who can forget his

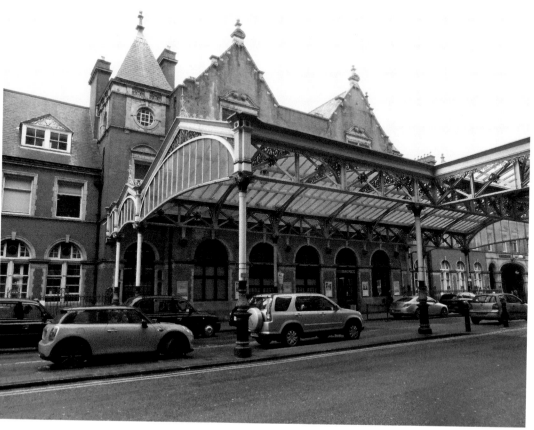

The front of Marylebone Station.

tribute to Miss Joan Hunter-Dunn and the immortal lines 'Come friendly bombs and fall on Slough/It isn't fit for humans now'? He loved the railways and he loved Metroland, the suburbs and the country areas that Marylebone Station served. He often used Marylebone and he liked it. The plaque reads as follows:

> Betjeman Centenary
> 2nd September 2006
>
> Chiltern Railways
> dedicate this plaque
> to the memory of
> Sir John Betjeman
> poet and friend of the railways
>
> 1906–1984

When I was at school I was, like many children of my generation, told not to use the word 'nice' when writing a composition. It seemed silly then and it seems silly now. It is a perfectly good word and an apt description of Marylebone Station. We start the journey at a nice place.

The Landmark London Hotel

At one time a very considerable number of railway hotels accompanied stations around the country, and many of them are still standing. They now often have other uses, but their heritage can sometimes be discerned from their names, architecture and other signs. Most of the London terminus stations had them and nearly all are still there. The Midland Railway's Midland Grand Hotel, designed by Sir Gilbert Scott, was perhaps the jewel in the crown. It is a Grade I listed building and has been gloriously restored as the St Pancras Renaissance Hotel. Its story is told in my book *Great Railway Journeys: London to Sheffield*, also published by Amberley.

The Great Central's London hotel was large and impressive. After a chequered history it became the Landmark London Hotel. It is in many ways different, but it is still large and perhaps even more impressive. The front entrance is in Marylebone Road and it is this that can be seen in the picture. The rear is in Melcombe Place, directly facing Marylebone Station. It is seven storeys high and occupies the whole of a block.

The hotel was opened in June 1899, three months after the station. It was commissioned at a time when a number of grand hotels were opening, the Savoy in 1895 being one of them, and the Great Central was ambitious. The architect was the highly regarded Colonel Sir Robert Edis. His innovative features included a completely glazed courtyard and a cycle track on the roof. The opening ceremony was conducted by the Duke and Duchess of Fife, which was an honour because the Duchess was the granddaughter of Queen Victoria and the daughter of the future King Edward VII. The honour, though, was not as great as that of the Midland Railway's Grand Hotel at St Pancras, which was opened in 1873 by Queen Victoria herself.

The opening of the Great Central Hotel was accompanied by a very upmarket charity bazaar that raised money for a new wing at St Mary's Hospital in Paddington. In the early years rooms were available on inclusive terms from 15s per day. As you will almost certainly know, inclusive terms means no extra charge for meals and 15s in pre-decimal currency is equivalent to 75p now. What an indication of the ravages of inflation! A fully inclusive day and night at the hotel cost about what a typical daily newspaper costs now.

Over the years the hotel entertained many famous guests and hosted many important events. An interesting one worth a mention is a welcome back breakfast held for Mrs Emmeline Pankhurst and other suffragettes in 1908, following their release from prison. The Landmark Hotel's website calls them political prisoners, which is a very debatable point. Their motivation was political and their cause was one that almost everyone now believes was just, but after a fair trial they had been convicted of breaking the law.

During the First World War the hotel was requisitioned by the military and served as a convalescent home for officers. After the Second World War it was used for the debriefing of former prisoners of war, and one of them was sentenced to fifteen years as a guest of His Majesty. MI9 officers established that Irishman James Brady had worked for the enemy. He had joined an Irish regiment of the British Army, but had worked for German intelligence after being captured in Guernsey.

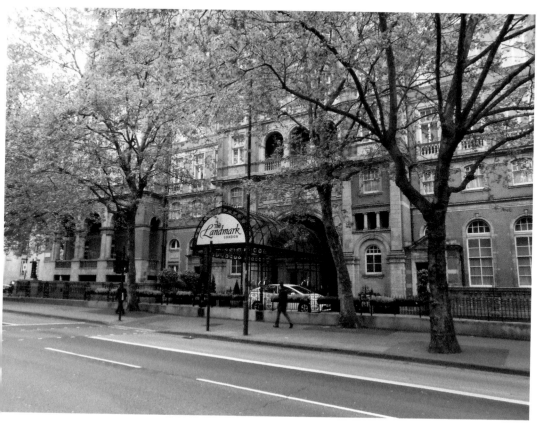

The front entrance of the Landmark London Hotel.

In 1945 the hotel was purchased by the London & North East Railway Company (LNER) and it was used as offices. Then, following nationalisation of the railways in 1949 it became the offices of the British Transport Commission, which later became British Rail. Starting in 1956 substantial changes to the building were initiated and some of the original grand features were removed. It acquired the nickname of The Kremlin, which seems rather harsh.

In 1988 Kentaro Abe bought the building and set about converting it back into a hotel. The substantial changes and improvements saw it return to something like (but not exactly the same as) its former glory. After two changes of ownership it opened in 1993 as part of the Four Seasons Group and with the name The Regent. One of the guests at the opening ceremony was the 3rd Duke of Fife, the grandson of the first Duke and Duchess who opened the original hotel in 1899. In 1995 it was bought by the Lancaster London Hotel Company and was renamed The Landmark London Hotel. It has five stars and in 2008 it became a member of the Leading Hotels of the World.

The hotel has 300 rooms, including fifty-one suites. There are extensive restaurants and bars, and the facilities include a spa and health club. On entering the first impression is of a very impressive atrium, and this extends up to the full height of the building. It is wide, light, airy, welcoming and well furnished. I tried to persuade myself that an à la carte lunch with wine would be accepted by HMRC as a legitimate business expense incurred while writing this book. I failed, but I enjoyed a tax-deductible coffee. If you have the time and money, it is worth a visit.

The Regent's Canal

The line crosses the Regent's Canal at right angles shortly after leaving Marylebone Station. This happens just before the train enters the tunnel that passes under Lord's Cricket Ground, so if you are in the dark without seeing it, you have missed the opportunity. However, if you are trying, you will see it, and you should gain an appreciation of the greenery and the tranquillity. You may see walkers, private boats and perhaps a larger pleasure craft carrying paying passengers. It is a lovely London amenity.

The canal links the Paddington Arm of the Grand Union Canal with the River Thames at Limehouse. It is just over 8½ miles long and incorporates three tunnels, the longest being the Islington Tunnel, which has a length of 969 yards. The route runs along the northern edge of Regent's Park and bisects London Zoo. It is stretching the imagination almost to breaking point, but it could be likened to an inner-London canal version of the North Circular Road. The canal was built before the railway age and a principal objective was to help take goods and materials from the River Thames and North London up to the Midlands. It brought things the other way too, of course.

Work started in 1812 and the first section was completed in 1816. The whole canal opened in 1820, when work on the second section was concluded. Financial difficulties delayed the construction and these were exacerbated by the embezzlement of funds by Thomas Homer, once the canal's promoter. He was sentenced to transportation. Another drain on funds was the cost of settling a dispute with a landowner.

Building the canal eventually cost £722,000, which was twice the original estimate. Major capital projects have a habit of costing more than planned. Things never change. In my book *London to Sheffield by Rail* I tell how the redevelopment of St Pancras Station

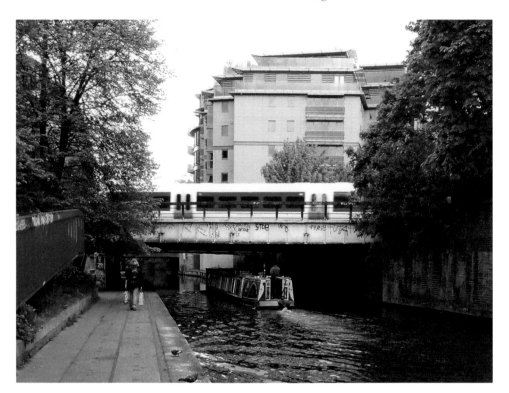

The Regent's Canal, passing under a train bound for Marylebone Station.

cost much more than planned, and in the next chapter but one I tell how the cost of the new Wembley Stadium escalated so alarmingly. It will be interesting to see how the final cost of HS2 compares with the original estimate.

The Regent's Canal was finished just a few years before the start of the railway age, and this meant that the anticipated profits were short-lived. It was initially heavily used, but commercial traffic declined and had virtually ceased by the 1960s. In the nineteenth century there were serious plans to convert the canal into a railway, but as it is still there it is stating the obvious to say that they did not come to fruition. In 1927 the Regent's Canal Company bought the Grand Junction Company, and together they became the Grand Union Canal Company. This was nationalised in 1948.

The canal is beautiful in parts and it has been called one of London's best kept secrets. It is now used by pleasure craft and in the summer months a waterbus runs at hourly intervals from Maida Vale to Camden. The towpath is used by cyclists and walkers. Quite a few cyclists use it for commuting. The London Canal Museum at Battlebridge Basin is worth a visit and so are the Camden Markets, which are located next to the canal. They contain an exciting collection of what seem like hundreds of stalls. Words to describe them would include quirky, modern and way-out. Unsuitable words would include upmarket and traditional. The stalls feature a vast array of such things as posters, cards, clothes, shoes, bags and music.

The famous architect John Nash was a director of the Regent's Canal Company, though his assistant John Morgan was appointed the canal's engineer. Nash was a friend of the Prince Regent and he successfully asked his permission to have the company and the canal

named after him. The nearby Regent's Park is also named after the Prince. It was Nash who built the much-loved Royal Pavilion in Brighton for him.

The Prince Regent, George Augustus Frederick, was the eldest son of George III, and he ruled as Regent from 1811, when his father descended into madness. The Regency lasted until his father's death ten years later, and he then ruled as George IV until 1830. He is fondly remembered as a patron of architecture and as a profligate collector of fine paintings, but history has not been kind to his memory. He was exceedingly extravagant, exceedingly fat and perpetually burdened by serious debts. He did not rule wisely and he was held in contempt by many of his subjects.

At the age of twenty-three he went through a form of marriage with Maria Fitzherbert, who was six years older than him and a twice widowed Catholic. The marriage was illegal because the Royal Marriages Act (1772) required the consent of the monarch. This was neither sought nor granted. Furthermore, the Act of Settlement (1701) prevented the spouse of a Catholic succeeding to the throne.

The perilous state of George's finances was an embarrassment and a scandal, and his father only agreed to help him on condition that he married his cousin, Caroline of Brunswick. His bride horrified him and they separated soon after the wedding. Among many other complaints he thought that she was unhygienic. George had a number of mistresses, both before and after the wedding. He also fathered a number of illegitimate children. It has been noted that many of his mistresses were grandmothers, so at least he cannot be accused of age discrimination. After nearly a quarter of a century apart, Caroline demanded to take her place as Queen at George's coronation. The King's attempt to divorce her failed, but he did manage to keep her away from the coronation. The people, however, very strongly supported Caroline.

On George's death *The Times* printed: 'There never was an individual less regretted by his fellow-creatures than this deceased King. What eye has wept for him? What heart has heaved one unmercenary sorrow? If he ever had a friend – a devoted friend in any rank of life – we protest that the name of him or her never reached us.'

If you are feeling charitable as you cross the Regent's Canal, you might reflect that Maria Fitzherbert was the love of George's life, and that he died with a miniature portrait of her hanging around his neck. Had their marriage been recognised, his life and his reign might have turned out much better; but, of course, they might not have. We will never know.

The Central Mosque of Brent

The Central Mosque of Brent is at Willesden Green and about 4 miles from the start of the journey. It is on the right side of the train, close to the line and just beyond Willesden Green Underground Station, which is on a separate line. You will see a prominent minaret with a green dome and another, smaller, green dome.

I visited the site around lunchtime on a Friday, which I did not know (but should have) is the principal day of prayer for Muslims. About 300 men and two women were milling around outside and then dispersing. Next-door to the mosque was a small building marked as being the Pakistan Community Centre.

After most of the people had gone I started taking notes and photographs, which probably made me seem rather suspicious. After a while a man came out of the Community Centre and politely asked if he could help, and when I had explained what I was doing he

invited me to join him inside, which I did. A group of men greeted me warmly, provided more than one serving of tea and biscuits, and invited me to ask questions.

Sunni and Shia are the two major denominations of Islam. There is a Shia Mosque nearby, but this is a Sunni one. It attracts around 2,500 worshippers and around a thousand are there at some time on a typical Friday. They were keen to tell me that it was not just a place of worship. They participate in charitable endeavours, and in particular they had a project to help homeless people. They were currently involved in a drive to increase voter registration in the area. In answer to my question I was told that women had a different entrance and worshipped separately. Writing as a non-Muslim, this made me uncomfortable. There is an emphasis on Islamic education and they host regular surgeries by the local MP and the police.

The hall provides space for more than 600 worshippers and a gallery takes 300 more. A separate women's section takes 400 and a smaller hall takes 300 for daily prayers. The basement is used as a community hall for functions and sport, and this hosts 600. It is used by worshippers on Fridays and when the number is particularly high, such as at the time of the Eid festival.

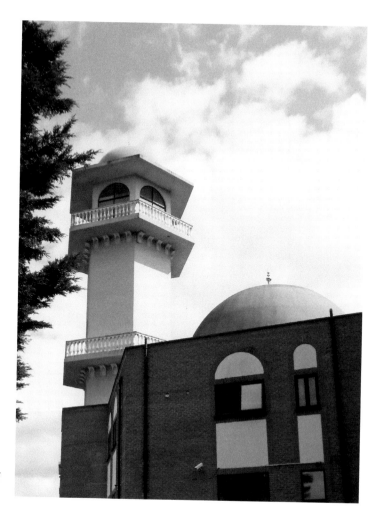

The Central Mosque of Brent.

The website indicated that there were five daily prayer sessions on every single day of the current month. The first was at around 4.20 a.m. and the last at around 10.45 p.m. During Ramadan there are seven prayer sessions every single day.

The Mosque came into being in 1976 and, following extensive work, the official opening to mark the 'new look' took place in 2005. The Pakistan Community Centre opened in 1981.

It will probably be apparent that I left Willesden Green with very warm feelings towards the people associated with the Mosque, and in particular towards those who made me so welcome. I thank them for their help and wish them well. However, there was something that gave me cause for serious thought. The building is a redevelopment of a redundant church, and the spire was converted into a minaret with a dome on the top. This is the dominant feature that can be seen from the train. It is symbolic of what is happening in many places. Churches are closing, congregations are falling and there is a shortage of ministers of religion. Christianity in Britain is on the decline, though some evangelical churches are bucking the trend. It is probably true to say that Britain is still a Christian country, but will this continue to be the case?

Wembley Stadium

What is usually regarded as England's greatest and most famous sports stadium is close to the line and is on the right side of the train. It is necessary to look up a small hill and the photograph captures the view that can be seen. The arch is 440 feet high and can be seen from a very long way away. I have seen it from Legoland at Windsor.

The last match at the old Wembley Stadium was played on 7 October 2000. A disappointing England team lost 0-1 to Germany, and a despondent Kevin Keegan resigned in the dressing room five minutes after the final whistle. The plan was to demolish the old stadium by the end of the year and to open the new Wembley Stadium in 2003, but a lot went wrong. As the project progressed, time and cost overruns became embarrassing. Originally budgeted at £326 million, the stadium finally came in at a staggering £797 million, and it was finally handed over on 9 March 2007, in time to host the 2007 FA Cup Final.

When it was opened most people were pleased with what they had eventually got. There is so much inside the complex that it is a kilometre around the perimeter. The seating capacity is 90,000 and it has a partially retractable roof. Of course there is the famous Wembley Arch with a span of 1,040 feet, which makes it the longest single-span structure in the world. The stadium is said to be the most technically advanced on the planet, though there are no doubt some who would dispute the claim. The facilities inside are breath-taking. You should have a brilliant view and (at a price) be very well looked after. The cost can be very considerable. A twenty-seat box on the halfway line for ten years costs £2.4 million. This covers all events at the stadium, but not food and drink.

It is interesting to record some of the differences with the old stadium that it replaced. All 90,000 spectators of course sit in roomy, individual seats, whereas in the old stadium they sat on long, uncomfortable benches. There are no pillars, whereas the old stadium had seventeen of them. Perhaps the most notable difference of all is that there are 2,816 toilets compared with just 380 in the old Wembley. The stadium has more toilets than any other building in Britain. Writing as a man who has watched a Wembley match with a restricted view while working out how to get to a toilet, it is a big improvement.

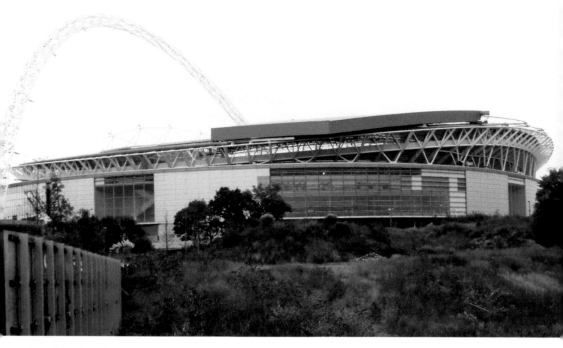

Wembley Stadium.

As you would expect, football is the main activity. Each year Wembley hosts the FA Cup Final and semi-finals, the League play-offs, the FA Community Shield, the final of the Football League Cup (currently called the Carabao Cup) and all of England's home international matches. There has also been the final of the Champions League and the football finals of the London Olympics. Apart from football there are major Rugby League games, one match each season from the American National Football League's International Series, and sometimes large concerts are held there.

The new Wembley Stadium inherited a mountain of nostalgic memories from the old one that it replaced, and it had much to do to build on its inheritance. The old stadium, famous for its twin towers, was built for the British Empire Exhibition of 1924, and, incredibly, it was originally intended that it be demolished in 1925. The first event held there was the 1923 FA Cup Final, which was not an all-ticket game. The official capacity of the ground was 127,000, but something like double that number crammed inside, with a further 60,000 stranded outside. Photographs show that they were nearly all men and that almost all of them were wearing hats. People did in those days, as mentioned in the chapter on Marylebone Station. The scope for a catastrophe was terrifying, but the afternoon passed without incident. Bolton Wanderers beat West Ham 2-0. David Jack had scored in every round and got both goals in the final.

The old stadium hosted numerous England international matches, five European Cup Finals, the final of Euro '96 and the annual FA Cup Finals, including the celebrated one in 1953 when Stanley Matthews put on a dazzling display and Stanley Mortensen scored a hat-trick to win the cup for Blackpool. Other sports using Wembley were Rugby League,

speedway and greyhound racing. These last two sports were very popular and regularly attracted enormous crowds.

The 1948 Summer Olympics were also held at Wembley. These were the friendly, austerity games and were held at a time of rationing. Some of the British competitors made their own kit and some took their annual leave from work in order to compete. The highlight of the games was a stunning performance by Dutch housewife Fanny Blankers-Koen. The pregnant thirty-year-old mother of two won four gold medals. She might well have won two more if she had not been restricted to competing in just four events.

Perhaps the most memorable event of all was the 1966 World Cup Final, when England beat West Germany 4-2. The citizens of East London call it the day that West Ham won the World Cup. The team provided the inspirational captain (Bobby Moore), the man who scored a hat-trick (Geoff Hurst), and the man who scored the other goal and was described by Sir Alf Ramsey as a player ten years ahead of his time (Martin Peters). It was the match that produced the most memorable quote in football commentary. As the final seconds ticked away and Geoff Hurst scored his third goal, Kenneth Wolstenholme said, 'Some people are on the pitch. They think it's all over. It is now.'

Apart from sport, in 1975 the American stuntman Evel Knievel jumped a motor bike over thirteen double-decker buses in front of a crowd of 90,000. He crash-landed, breaking his pelvis, vertebrae and hand. In 1985 Prince Charles and Princess Diana opened the Live Aid Concert, which Bob Geldof inspired and did so much to promote. It was widely reported, not always favourably, that Prince Charles seemed to be the only man in the stadium wearing a tie. As an inveterate tie man I think that His Royal Highness got it right.

I can thoroughly recommend the seventy-five-minute Wembley Tour. Booking details are on the website: www.wembleystadium.com. My review of Wembley Stadium has been favourable, which was not what I expected. I had not previously visited the new stadium and I approached it in a negative frame of mind, caused partly by the delays and the massive cost of building it. However, I was won over; Wembley Stadium is magnificent.

Denham Golf Club Station

Denham Golf Club Station is at the village of Upper Denham, a mile or so after Denham Station and slightly more before Gerrards Cross. The golf course cannot be seen from the station but it is nearby, just behind some trees and a road on the right side of the train.

In Edwardian times the Denham golfers must have been very influential. At their request the Great Western and Great Central Joint Railway opened this additional station on 22 July 1912. Its purpose was to serve Denham Golf Club, which had opened the previous year. The station was originally called 'Denham Golf Club Platform'.

The original Up platform was made of wood and there was a path connecting it to a track leading to the golf course. The golfers were probably fit, because although the entry point to the course was close to the station, it was necessary to walk across it to reach the clubhouse. This had to be done before the golfers started their eighteen-hole round.

Between the two world wars the platforms were lengthened and the station was made a halt. The two very small covered waiting areas are original Great Western 'pagoda' shelters. The ticket office was at road level below the line, and this too was a pagoda building. All

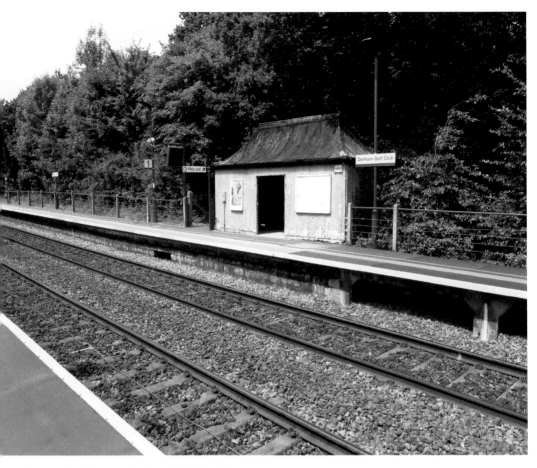

A pagoda shelter at Denham Golf Club Station.

three structures were listed in 1992. This was done to prevent them being replaced by the more functional 'bus shelter' structures generally used elsewhere. Following a fire the ticket office was replaced in 2007, but the replacement was built in the same style as the original. It does not, though, have a clerk's window.

The station is unstaffed and has charm, but it does not have many passengers. It is safe to say that all, or at least almost all, the golfers and their visitors now make their way to the course by road. My mid-afternoon visit lasted an hour and I did not see a single person on the platforms. In a twelve-month period ending in 2015/16, 21,072 tickets were sold for journeys starting or ending there. This is an average of less than sixty people a day.

The very small number of passengers is surprising. Outside of the busiest periods trains run from Denham Golf Club to London Marylebone at about hourly intervals, but the service is more frequent at busy times. The first train to Marylebone is at 5.49 a.m., and the quickest takes just twenty-three minutes. The absence of a car park might be one of the reasons that the station is so little used. Another could be that the road to and from it is narrow, and in fact there are passing places for people coming from the least used direction.

The station is mainly used by people living in the nearby houses and bungalows. At least one of the occupiers clearly has an affinity with the line and the station. The outside wall of a rather grand property displays an original brass notice. It is headed GC&WR and it states that 'Any person leaving this gate open is liable to a penalty of forty shillings'.

The nearby golf club is a private members' club and it welcomes visitors. The golfers are fortunate that the drainage is very good and for this reason the course is rarely closed. The clubhouse dates back to the seventeenth century and has excellent facilities, both for golfers and for people hiring it for functions. It is a licensed wedding venue.

Denham Golf Club Station has its roots in a very different age and it has a fascinating story. Furthermore, it is a fully operating unmanned station and it provides a useful service for not many people. Nostalgia is not what it used to be, but I left feeling nostalgic in a happy way. I will probably not return, but I just might.

The M25 Motorway

The line crosses above the M25 motorway about 2 miles after leaving Denham Golf Club Station and shortly before reaching Gerrards Cross. The photograph was taken on a Friday afternoon from the nearby bridge that takes the A40 road over the motorway. The traffic on the motorway was heavy in both directions. Vehicles were moving in both directions, but only slowly. Numerous readers will recognise this as an all too familiar scenario. Indeed, many will think that it was better than is often the case at that time on a Friday.

The book has contained no literary quotations since the poems of Sir John Betjeman were quoted in the first chapter. The connection is very tenuous, but let me atone for this deficiency by bringing in the opening words of *Pride and Prejudice*, written by Jane Austen in 1813. They are: 'It is a truth universally acknowledged that a single man in possession of a good fortune must be in want of a wife.' Culture and the M25 are not obvious bedfellows, but in the same spirit we could say 'It is a truth universally acknowledged that one of the world's greatest cities must be in need of an orbital road'.

The story starts as long ago as 1905 with recommendations by a Royal Commission on London Traffic. These included roads similar to what we now call the North Circular and the South Circular. Some evidence to the committee proposed another ring further out. By 1924 much of the North Circular was under construction and by 1935 streets were joined to form the tortuous South Circular. This was decidedly unsatisfactory because, as existing streets were linked together, there were many junctions and it did not link with the North Circular in the west. The roads were nothing like motorway standard. In 1934 there were 2.4 million vehicles in Britain; there are around 38 million now.

The first coherent proposal for a proper orbital road round Greater London was made in 1934 by the Engineer to the Ministry of Transport. It was to be 18 to 20 miles out from Central London, and had many similarities to the eventual route of the M25. There were further proposals in 1944 and up to 1966. None of them was actioned.

The one that was built was announced by the Minister of Transport in 1975 and it was to incorporate some high-quality roads that had been built in the early 1970s. The route was 117 miles long and included a new bridge over the River Thames, a new tunnel under the river and the utilisation of an existing tunnel. These were technically not part of the motorway. It was opened in sections and the ring was completed in 1986. As you look down

on the motorway you may see free-flowing traffic, though it will undoubtedly be busy. On the other hand you may see slow-moving traffic or a complete stoppage. If it is the latter you may understand why it is sometimes called the biggest circular car park in Britain.

It is another truth universally acknowledged that British motorways are not built to an adequate specification, and the M25 was no exception. It was designed for a maximum of 88,000 vehicles per day, but by 1993 it was handling 200,000 vehicles per day. Consequently it has been regularly widened and improved – a process which is continuing. It would have been cheaper and better to have been more ambitious, but as a taxpayer I can understand why this did not happen. The number of vehicles using it is now considerably greater.

The M25 has numerous fixed cameras in each direction, both clockwise and anticlockwise. You may be relieved to know that they are not all used for enforcement purposes, though it might sometimes seem like it. In addition there are frequently temporary enforcement cameras because of roadworks. Prosecutions for speeding are becoming harder to avoid because of the sneaky practice of recording average speeds between fixed points. As a law-abiding and safety-conscious citizen you will no doubt welcome this, but it might be hard to be pleased when you open an envelope and find a 'Notice of Intended Prosecution'. I write these words after having driven 250,000 miles without an incident and having opened such an envelope.

Having got this off my chest but still feeling grumpy, I will bring in the Dartford Crossing. This is the Queen Elizabeth II bridge that crosses the River Thames in a clockwise direction and the two tunnels that take traffic under the river the other way. The tunnels were open before the motorway was built and the bridge, which carries up to 150,000 vehicles a day, was completed in 1991. Since 2014 it has not been possible to pay the toll in cash at the bridge. Payment must now be made online, by text message, by phone or with a pre-pay account. It is another step in the relentless move to phase out cash and make life more troublesome for us. On a more cheerful note the motorway, which is 117 miles long, was formerly woefully deficient in service areas but now has four of them. This is just under one every 30 miles on average.

An account of the M25 motorway would not be complete without some extraordinary facts. Here are three of them:

- The highest speed recorded by the police is 147 mph.
- An 84-year-old man spent 48 hours trying to find the turn off that he wanted.
- The police detained an elderly lady cycling on it in the wrong direction.

Work to widen and improve the motorway continues, though it sometimes feels as if we are running to stand still. A major issue is what will happen if and when a third runway is built at Heathrow Airport. The options are diverting the motorway, putting it in a tunnel and putting the runway in a ramp over it. If the extra runway is built, whichever option is chosen will cause many years of disruption for users of the motorway. Also the new runway, when complete, would increase the number of passengers using the airport, the number of people working at it and the number of vehicles using the M25. The country does need the extra airport capacity though.

Almost everyone has at least one M25 story and I have several, so this chapter ends with an account of the hobby of the father of one of my son's friends. In the early days of the motorway he would frequently drive the complete lap, trying to beat his best time. He made it an absolute rule never to break a speed limit. He did this many times, including at night. Sad, isn't it?

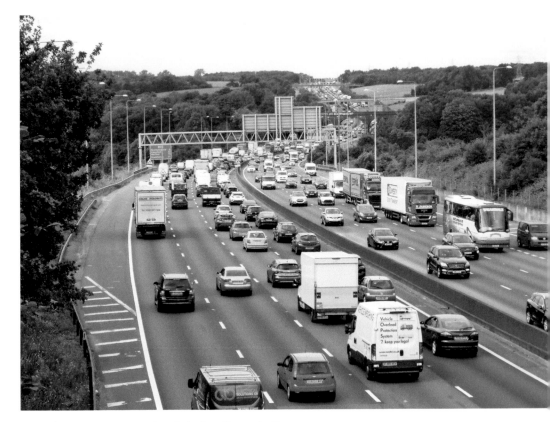

The M25 motorway shortly before Gerrards Cross.

Gerrards Cross

The small town (or technically large village) of Gerrards Cross is situated roughly halfway between Denham and Beaconsfield. The 2011 census puts the population at 8,017. It has a lot of charm and a lot of money – or more accurately, some of the people who live there have. It is set in beautiful countryside and Central London is 19 miles away. The quickest train to London's Marylebone Station takes just twenty-five minutes, so it is not hard to see why it is attractive to commuters. Some of the houses are splendid and property prices are astronomic. In fact, surveys show that it ranks very highly indeed in league tables of property prices outside London. People wanting to buy one of the better houses need a great deal of capital; the bank of mum and dad is unlikely to have sufficient funds.

Shortly after passing over the M25 motorway the train travels through the outskirts of the village. It then enters a short tunnel and emerges into a deep cutting. Gerrards Cross Station is in the cutting. Tesco, which is shown in a photograph accompanying this chapter, is just behind a road bridge at the end of the tunnel. It can be seen by looking backwards from the station. The store has been built directly over the tunnel.

Readers of a certain age may recall a wrestler called Mick McManus, who was billed as 'The One You Love To Hate'. For some reason quite a few people feel the same about Britain's biggest supermarket, Tesco. Perhaps it is because it is sometimes accused of abusing its dominant position. It is said that when it opens in a new area, existing much-loved stores are driven out of business. For whatever reason there was considerable local opposition to its coming to Gerrards Cross and the local council opposed the plan. However, the responsible minister, John Prescott, upheld the recommendation of a planning inspector and overruled the council, with work then starting in 2003. In order to accommodate the store it was necessary to build a new tunnel. This used pre-cast concrete sections, which were connected to each other. Material was then backfilled over the top.

On 30 June 2005 the tunnel collapsed during the course of construction and a railway disaster was only narrowly averted. A London-bound train was just moving from Gerrards Cross Station when its alert driver saw what had happened. He used his radio to inform the signallers and they stopped other trains, including one coming the other way that had left Denham Golf Club Station. There were no deaths or injuries, but had the tunnel and the backfilling come down on a train during rush hour it would have been a calamity. The line was closed for nearly eight weeks, with buses taking passengers around the blockage. The store finally opened in 2010, five years later than originally planned.

Opposition to the coming of Tesco to Gerrards Cross was strong and the tunnel collapse seems quite a coincidence. No one really thinks that the Almighty was responsible, but it is a fanciful thought. In 1984 a lightning strike caused a serious fire at York Minster. Three days earlier the controversial Dr Jenkins had been consecrated Bishop of Durham in the building, and a few religious people wondered if what happened was a mark of God's displeasure. In 1834 the Houses of Parliament were destroyed by fire and some thought that it was divine retribution for the 1832 Reform Act. Queen Adelaide was reputedly one of them. Despite the opposition to the Tesco store, a lot of local residents were happily patronising it during my visit.

If you look hard on the right side of the train, and if it is travelling slowly (or if it stops, of course), you will see a delightful bronze statue entitled *Victorian Railway Navvy*. It is on the Up platform. As its title suggests it depicts a navvy, one of the remarkable breed of men who were indispensable in building Britain's rail network. These were the people who had built the canals some years previously. The word 'navvy' is an abbreviation of the word 'navigator'. The statue was commissioned by the Colne Valley Park Groundwork Trust and was unveiled on 3 September 1992 by John Nelson, Managing Director for Network SouthEast.

The renowned sculptor was Anthony Stones, who was British by birth but had spent much of his adult life in New Zealand. He was president of the British Society of Portrait Sculptors from 1999 to 2004. Unlike some members of his profession his work is realistic and accurately portrays his subjects. He was prolific and his legacy includes an equestrian statue of Bonnie Prince Charlie for the City of Derby.

What else should we know about Gerrards Cross? For a start, it is named after the Gerrard family, who owned a manor in the area in the early part of the seventeenth century. It has a golf club and a cinema – not many villages, even large ones, can say that. The Gerrards Cross Memorial Building was designed by Sir Edwin Lutyens and unveiled in 1922. It commemorates the dead of the First World War and is a rare example of a war memorial having a functional purpose. The village is on the right bank of the River Misbourne, a chalk stream that rises near Great Missenden and joins the River Colne. It is an attractive place to live. If you have a spare million pounds or so, you might consider buying a house there.

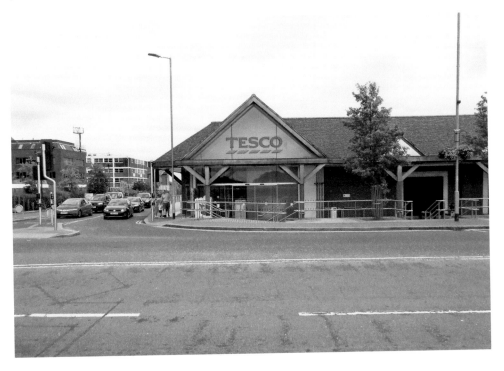

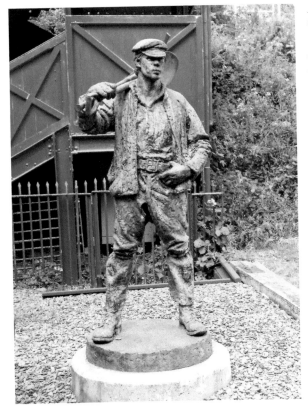

Above: The Tesco store in Gerrards Cross.

Left: The *Victorian Railway Navvy* statue.

The Chiltern Hundreds

The photograph accompanying this chapter was taken from a point on the line shortly after Gerrards Cross. It is rather a nice field that was randomly selected from a large number of candidates. Its significance is that it lies within the boundaries of the Chiltern Hundreds. The line runs through the three hundreds that are used by a Member of Parliament wishing to resign from the House of Commons.

Since 1624, death, disqualification and expulsion have been the only means by which a Member's seat may be vacated during the lifetime of a Parliament. A Member may not just resign his or her seat, so it has to be disqualification. A Member accepting the position of Crown Steward and Bailiff of the three Chiltern Hundreds of Stoke, Desborough and Burnham ceases to be an MP. Holding both positions simultaneously is not permitted.

A Member applies for the position. The application is considered by the Chancellor of the Exchequer, who could, in theory at least, say no. However, this has not happened since 1842. As soon as the application is accepted, the applicant ceases to be an MP. He or she then resigns from the Chiltern Hundreds, leaving the position vacant for the next applicant. The position of Crown Steward and Bailiff of the Manor of Northstead is used in the same way. The positions are sinecures and carry no rights or responsibilities.

'Hundreds' date back to Saxon and Norman times and were administered by an elder. Later, a steward and bailiff was appointed by the Crown. They were divisions of English counties that could raise a hundred fighting men for the service of the monarch. The position of steward and bailiff was a legal one, answerable to the King or Queen, and the

A field in the Chiltern Hundreds.

duties were to maintain law and order in the designated area. By the reign of Elizabeth I the duties were redundant because they had been taken over by Justices of the Peace, Sheriffs and Lords Lieutenant. By the seventeenth century certain Crown Stewards and Bailiffs still existed, but they had no powers and no duties.

As you gaze out of the window you may perhaps experience feelings of pride at the splendid peculiarities of what the Duke of Wellington once called 'our matchless constitution', which, until 1832, allowed a very small number of electors to choose Members of Parliament. Some of them voted in so-called rotten boroughs, the rottenest of all being Old Sarum, which sent two MPs to Westminster. It was controlled by just one man and at one time one of the borough's representatives was the Prime Minister, William Pitt the Elder. One likes to think that were he to be with us today, the Duke would see things differently. On the other hand, you might think that antiquated devices like applying for the Chiltern Hundreds have long had their day and should be replaced by a modern arrangement.

As the train moves along you might think about a particular MP who you believe should do the decent thing and use the device and leave the House of Commons. If you are in an especially bad mood, you might even want all 650 of them to do it. The Chiltern Hundreds can deal with a number of applicants in a short period of time. In 1985 seventeen Ulster Unionist MPs left the House of Commons in protest at the Anglo-Irish Agreement. Northstead and the Chiltern Hundreds coped with all of them on the same day. Your political views are a matter for you, but whatever they are enjoy the view.

Beaconsfield

Beaconsfield is 4 miles beyond Gerrards Cross and its station is also in a cutting. Although it is a small town with a population of just over 12,000, while Gerrards Cross is a large village, the two places have much in common. Both are very pleasant and are surrounded by beautiful countryside, and both contain some fine and very expensive property. Each is ideal for prosperous commuters.

Beaconsfield has an old town and a new town. The old town can trace its origins back to 1185. It has a very wide central street and a number of old coaching inns. They were once the first stop for coaches making the trip from London to Oxford. There is an area of Georgian and neo-Georgian, and Tudor architecture, and there is a market every Tuesday. The fine parish church is dedicated to St Mary and was rebuilt in 1869.

The station is a mile from the centre of the old town and the new town grew up around it from the early part of the twentieth century. It now links to the old town. The new town has a different feel, but it too is an attractive place. I can recommend coffee and cake at Jungs. This outstanding café and bakery has its roots in Germany and Switzerland and is now run by the third generation of the owning family. My visit put me in a good mood for seeing Bekonscot Model Village, which is nearby.

Bekonscot is close to the station in new Beaconsfield and has the distinction of being the world's oldest model village. It is much loved and justly famous. Its origin was in 1928, when Mrs Callingham told her husband that she would leave if he did not get his model railway out of the house. Roland Callingham, a wealthy accountant who lived in Beaconsfield, obliged, and put it in their large garden. He then started adding model

buildings and other features to accompany it. His cook, maid, gardener and chauffeur helped him and it got bigger and bigger. The model village was not originally open to the public and he did it for his own pleasure and to entertain friends and visitors. In 1930 he started admitting the public. Originally there was no charge, but visitors were asked to consider a donation to charity.

In 1934 Princess Elizabeth was brought over from Windsor just before her eighth birthday. She loved it and has been back several times. Her children have also been, as has Princess Margaret, Queen Mary and George VI.

In time Callingham's work expanded to cover 1½ acres. He called it Bekonscot, an amalgamation of Beaconsfield and Ascot. It developed into six separate villages on the one site. A model railway links and criss-crosses all of them and the whole development is nostalgically set in the 1930s. The six villages comprise an improbably large number of features, including (but not limited to): a harbour and pier, a coal mine, a racecourse, Morris dancers, a cricket match, a windmill, a castle, a zoo, an aerodrome and pre-war cars.

The scale is 1 in 12, so a 24-foot-tall structure is represented with a height of 2 feet. The railway is to a scale of 1 in 32. Some rather tortured wit can be discerned; one business is given the name Lee Key Plumbers' Merchants (Leaky) and another is Sam and Ella's Butchers (Salmonella).

Twelve full-time staff are employed, with another twenty in the summer season. Right from the start all profits have been given to charity. Since 1978 the Church Army has co-managed it, taken some of the profits and helped distribute the remainder. Since 1930 Bekonscot has received about 15 million visitors, but this does not mean that 15 million separate people have attended; I have been a number of times, with my parents, my wife and children, and with my grandchildren.

Considering that Beaconsfield is only a small town and was once smaller, many famous people have lived there. One who deserves a special mention is the children's author Enid Blyton. She was a remarkable woman and her life was a whirlwind of activity. For thirty years she lived in a large house in new Beaconsfield called Green Hedges. This was for the last years of her life until she died in 1968 at the age of seventy-one. It was later demolished and the site was incorporated into a new residential road. This was named Blyton Close in her honour, and a photograph of the road sign has pride of place in this chapter.

Enid Blyton started her career as a teacher, but she went on to write more than 600 books and her continuing sales have exceeded 600 million copies. Her work has been translated into ninety different languages. Not only that, she set up and ran clubs for children, wrote articles and was involved in charities.

Her family life did not always match the ideals that were generally portrayed in her books. She had a distant relationship with her separated parents and did not attend either of their funerals. Nor did she invite them to her first wedding in 1924. After a while her husband suffered trauma, probably caused by his experiences in the First World War, and he developed a dependency on alcohol. Husband and wife each had affairs and in 1942 the marriage ended in divorce.

Blyton swiftly married a surgeon with whom she had been conducting an affair, and it appears that the second marriage was generally happy. However, it has been claimed that she denied her first husband access to their two girls, and it has also been claimed that she ensured that her first husband could not work in publishing. Gillian, her eldest daughter, spoke of her favourably and with affection. Imogen, her other daughter, did not share these feelings and wrote about her mother in harsh terms.

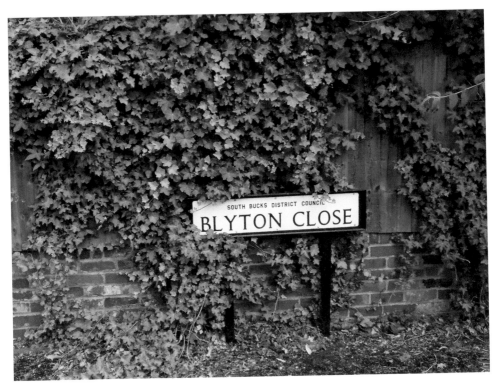

Blyton Close – a tribute to the children's author.

Blyton's characters included the Famous Five (Julian, Dick, George, Anne and Timmy the dog), the Secret Seven and of course Noddy and Big Ears. Children loved stories about Mallory Towers (the girls' school), the Faraway Tree and many others. She worked with a typewriter on her lap and wrote without a preconceived idea of the plot. She drew on her subconscious and this, together with her prodigious output, led to claims that she plagiarised herself and others.

The figures speak for themselves. Her books were loved by millions of children, but not always by adults. Many libraries would not stock them as it was claimed that they had a limited vocabulary and little literary merit. Furthermore, it was sometimes said that they were some combination of elitist, racist, sexist and xenophobic. It was hard to see that the Famous Five were racist or xenophobic, though they might be accused of sexism. It was always Anne who prepared the picnic. Were they elitist? It is hard to label Timmy the dog, but the four children were obviously middle class or perhaps even upper middle class. In fairness, if we read them today we should measure them by the standards of a previous age. As L. P. Hartley said: 'The past is a foreign country. They do things differently there.'

Blyton herself had a splendid answer for her critics. She said that she was not interested in the views of anyone over the age of twelve. Her great service to the nation was that she got children reading for pleasure. They started with her books and then moved on to other writers. I was one of the ones who did this. I was a slow starter but then I discovered Enid Blyton and things changed. My children and grandchildren were quick starters and they did the same. Thank you Enid. You did a good job.

Benjamin Disraeli, who was Prime Minister in 1868 and from 1874 to 1880, lived at Hughenden, a few miles away. He was MP for Buckinghamshire and in 1876 he took the title Earl of Beaconsfield. Edmund Burke, the eighteenth-century statesman, is another prominent politician with connections to the town. He was buried there in 1797. Politics aside, a search will reveal a long list of prominent people who have lived in Beaconsfield. G. K. Chesterton and Robert Frost are two writers who did so.

Gomm Valley Nature Reserve

Gomm Valley Nature Reserve is 3 miles beyond Beaconsfield and at the very eastern edge of High Wycombe. As its name suggests it is long and thin, running down a steep, dry valley. It can be seen on the right side of the train as it crosses a high bridge. The tip of it comes down to a point 40 yards from the line. The photograph shows the wooded edge of the reserve with the railway bridge beyond the end.

The reserve is owned by the Berks, Bucks and Oxon Wildlife Trust and is a Site of Special Scientific Interest. It covers an area of 4 hectares. If, like me, you are not familiar with the size of a hectare, it might be helpful to mention that it is 10,000 square metres, or 2.47 acres. Visitors have created a number of paths through the reserve.

The edge of Gomm Valley Nature Reserve.

Much of it is covered with scrub species. The Trust's website mentions dogwood, hawthorn, buckthorn, spindle, guelder rose and wayfaring-tree, but there are many others. The combined effect is to give a spectacular display of blossom in the spring. The autumn berries provide food for flocks of birds, particularly from the thrush family. Bee, pyramidal and common spotted orchids are among the many types of flowers that are there. In some years the scarce coralfoot, which produces dainty pink clusters of flowers in late spring, may also be observed.

Over a period of twenty-five years more than thirty species of butterfly and more than 180 species of moth have been recorded. The common lizard (*Lacerta vivipara*) and slow worm (*Anguis fragilis*) are regularly seen.

High Wycombe

High Wycombe is 5 miles beyond Beaconsfield. The 2011 census put the urban area population at 133,204, which makes it one of the biggest towns encountered on the journey. I should know a lot about it because, although I grew up in and near Aylesbury, I was born there. Furthermore, aunts, uncles, cousins and both sets of grandparents lived in the town.

I should and do know a lot about High Wycombe Station, because some of my early trainspotting was done there. One of my happiest childhood memories is of being taken by my grandmother to watch the trains at the station at the age of seven. A kindly engine driver offered to take me for a ride, and with my grandmother's permission I stood on the footplate as the engine was repositioned from one end of a train to the other.

The railway came to High Wycombe in 1854. It was the terminus of the Wycombe Railway and linked to the Great Western line at Maidenhead. The Wycombe Railway was owned by the Great Western and was built with Brunel's famous broad gauge of 7 feet ¼ inches. The line was extended to Thame in 1862 and a second through station was added at High Wycombe in 1864.

The Great Western & Great Central Joint Line was built through High Wycombe in 1906. At this time the station was again rebuilt and it became the one that can now be seen. It has four lines between two staggered platforms and there was a subway, which has now been replaced by a bridge. The original line to Maidenhead (no longer broad gauge of course) was closed in 1970. The line and station were built into the side of a hill and a notable feature is the very tall and long retaining brick wall that extends through and beyond the station.

The photograph is of the original 1854 Brunel-designed terminus building. It is adjacent to the line, on the left side of the train, not far away and very easily spotted. It is best seen from the front of the platform. It originally contained a single platform and two lines. Ten years later it became a booking office, locomotive storage shed and an engine workshop. In 1870 it was converted to a goods shed and it subsequently had a number of different uses.

The building was saved from demolition in 2009 when it became Grade II listed. Most of the additions were removed and it was restored to its original state. The mural seen in the photograph was designed by a local artist, Dan Wilkinson. It features an Iron Duke class locomotive in a platform setting. The intention is to show the scene as it appeared in the 1860s. The mural was painted by Dan Wilkinson and Soulful Creative, and the effect is compelling.

High Wycombe is very old indeed. The earliest indication is the remains of a Roman villa. An excavation, among other things, revealed mosaics and a bathhouse. The existence of a settlement was first documented as Wicumun in 970 AD. The town is mentioned in the Domesday Book of 1086 and it was recorded as having six mills. It received borough status in 1222.

The town is (or at least was) famous for its furniture industry, which developed in the nineteenth century. The availability of raw material in the nearby beech woods was a factor in this, and it is interesting to note that the nickname of Wycombe Wanderers Football Club is 'The Chairboys'.

High Wycombe was particularly famous for Windsor chairs and in 1875 4,700 of them were leaving the town each day. This is equivalent to well over a million each year. It was before motor traffic, so there must have been a lot of horse-drawn carts clogging up the roads. There must also have been a lot of horse manure to enrich the gardens of the town. When Queen Victoria visited High Wycombe in 1877 she passed under a massive arch of chairs that had been constructed over the High Street. The words 'LONG LIVE THE QUEEN' were prominently displayed along the top of it. Furniture making flourished until the 1960s, but it has now virtually finished.

High Wycombe is now very different. Like many places in the south-east of England the population has greatly increased. The number of inhabitants has more than quadrupled from the 28,000 who lived there in 1928. There has been massive redevelopment and a new shopping centre. Many students attend the redeveloped Buckinghamshire New University, which has a large student village. Some parts of the town may be classed as deprived areas, however, so it is not without problems.

A charming local custom deserves a mention. High Wycombe has an unbroken line of mayors going back to Roger Outred in 1285, and since 1678 it has been the practice to weigh the mayor at the beginning and end of his or her term of office. The ceremony is performed in public, employing the weighing apparatus that has been used since the nineteenth century. The actual weight is not disclosed. After the second weighing the town crier will say 'And no more' if there has not been an increase, or 'And some more' if there has. The origin of the practice is presumably to indicate whether or not the mayor might have eaten richly at public expense. An account of the town would not be complete without some facts about the ruins of the Hospital of St John the Baptist, and also the still active All Saints Parish Church.

The ruins of the Hospital of St John the Baptist are close to the station, but they cannot be seen from the train. The hospital was founded in about 1180, and was inhabited by a small community of brothers and sisters. They cared for the poor and, in effect, ran almshouses. Three beds were kept for poor or infirm people passing through the area. In 1239 a papal decree gave permission for the building of a chapel. The hospital and chapel were closed in 1548 as part of Henry VIII's Dissolution of the Monasteries.

In 1550 the buildings were acquired by the mayor and burgesses for the establishment of a school. This was granted a royal charter by Elizabeth I in 1562 and became known as the Royal Grammar School. It still has this name, though it moved to new premises in 1883. Most of the structure was then demolished, but some of it is still visible. The remains include a small part of the chapel, dating back to 1239. Columns and arches can be seen and a visit, in my opinion at least, cannot fail to be interesting. The ruins were classified as a national monument in 1993.

All Saints Parish Church is in the centre of the town. Bishop Wulfstan consecrated the first church on the site more than 900 years ago. It was rebuilt in 1275 and a new tower was completed in 1522, with the pinnacles being added in 1755. The tower contains a peal

of thirteen bells. The former Prime Minister William Petty, the 2nd Earl of Shelburne, is buried in the church vaults. The entrance to the vaults was subsequently tiled over and the exact burial position is not marked, which is rather surprising. There is no memorial to him either.

The Christian people of High Wycombe would be disappointed if I just mentioned the church's history and did not say that it is very much thriving. Judging by its website, it certainly is. Looking at the height of the holiday season I see that twenty religious services are scheduled for the next seven days. There will also be four other events and the café will be open for four of the days.

Wycombe Abbey is a very highly regarded independent boarding school for girls. Founded in 1896, it takes around 615 girls. Several of its buildings are Grade II listed and it is in extensive grounds totalling 170 acres. If you have read the previous chapter and if you are good at maths, you will be able to calculate that they are seventeen times bigger than the Gomm Valley Nature Reserve.

The building was requisitioned in 1942 and was the headquarters of the United States Eighth Army Air Force. As you would expect the school has a long list of distinguished former pupils. However, they would not be pleased to be reminded that one former pupil pleaded guilty in the United States to the charge of accessory to murder before the fact. Her parents were the murder victims. In 2016 Wycombe Abbey entered into a partnership with British Education Limited, permitting it to launch a school in China.

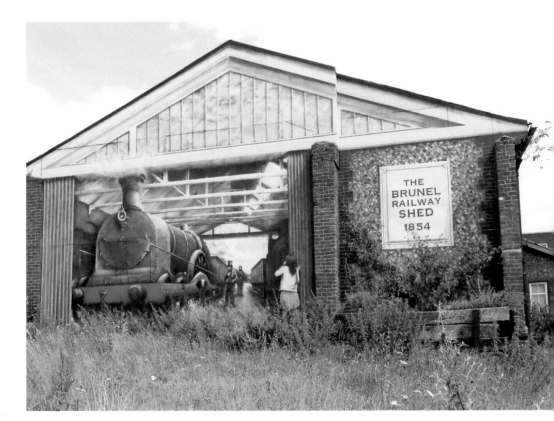

The 1854 Brunel railway shed.

Two Prime Ministers had very close connections with High Wycombe. Benjamin Disraeli, who was three times Chancellor of the Exchequer and twice Prime Minister, spent part of his early adult years at nearby Bradenham and lived at Hughenden Manor on the northern fringe of the town. He three times tried unsuccessfully to be an MP for the borough of High Wycombe, but spent most of his career as MP for Buckinghamshire. There is more about him in the chapter on Bradenham and Bradenham Manor.

William Petty, 2nd Earl of Shelburne, was Prime Minister for 235 difficult days in 1782–83. He went to the House of Lords at the age of twenty-four, but prior to that he was MP for the borough of High Wycombe. One of his homes was what is now Wycombe Abbey School, and, as already mentioned, he was buried at All Saints Parish Church in the town. Shelburne is one of the four Prime Ministers to have fought a duel. He was slightly injured in the groin, but made light of it. 'I don't think Lady Shelburne will be the worse for it,' he said.

Wycombe Wanderers Football Club has been owned by The Supporters' Trust since 2012 and has the reputation of being very family friendly. As an occasional visitor with my grandson, I can confirm that the reputation is justified.

The club played at Loakes Club in the centre of the town from 1895 to 1990. The pitch sloped from side to side, the drop being 8 feet at one end and 11 feet at the other. A long-running joke had it that visiting teams trained by running along the street with one foot in the gutter. In 1947 the club's former captain, Frank Adams, who had become a successful businessman, bought the ground and gave it to the club. In recognition of this extraordinary generosity, when the Wanderers moved to a new ground at the edge of the town in 1990 it was named Adams Park.

For a long time Wycombe Wanderers was a successful amateur team. It won the FA Amateur Cup in 1931 and was runner-up in 1957. It won the Isthmian League twice in the 1950s and subsequently four more times. Led by the charismatic manager Martin O'Neill, it was promoted to the Football League for the 1993/94 season. There have been many ups and downs and the appointment and sacking of several managers. There have been a number of outstanding cup performances and the greatest of them was the FA Cup run in the 2000–01 season. This finished with a 2-1 defeat to Liverpool in the semi-final. At the time of writing, the club is close to the foot of Division 1.

St Lawrence's Church at West Wycombe and the Dashwood Connection

The village of West Wycombe is a gem and is very closely associated with the Dashwood family and its history. It is 3 miles beyond High Wycombe Station and contains West Wycombe Park and its house. These are close to the line, but are not visible from the train. The nearby hill is on the left side of the line and the golden ball on top of St Lawrence's Church can clearly be seen. The Dashwood Mausoleum is next to the church and both are at the top of the hill. The Hellfire Caves are inside the hill. All have interesting stories, which is why this is one of the book's longest chapters, but it is worth starting with an account of the Dashwood family.

Sir Edward John Francis Dashwood, 12th Baronet, is the Premier Baronet of Great Britain. The title was bestowed on the first Baronet in 1707, shortly after the union of England and Scotland. Sir Francis, as the first Baronet was known, came from a prosperous trading family and made a lot of money importing silk and other goods. He was an MP for four years and his fortune increased by means of four financially advantageous marriages, two of them contracted after being made a Baronet.

His namesake, the 2nd Baronet, Sir Francis Dashwood, is the most famous, not to say infamous of the twelve. The reasons for his infamy, like the news of Mark Twain's death, are often greatly exaggerated, but he has a very interesting story. Some of it is left to the account of the Hellfire Caves at the end of this chapter. For now it should be recorded that in his early adult years he travelled very extensively and spent much time in Italy, and that he was prominent in the founding and membership of a number of clubs. Aspects of the clubs were worthy but alcohol and disreputable behaviour featured, as they did in his travels.

In early middle age Sir Francis began to take an interest in politics, and was for a year Chancellor of the Exchequer in the short administration of the 3rd Earl of Bute. He became Lord Lieutenant of Buckinghamshire and for fifteen years was Joint Postmaster General, in which post he achieved considerable success and enjoyed a reputation for integrity. This was not something that could be said of many politicians active at the time. In his latter years, despite his former hellraising, he played a major part in the revision of the Church of England's *Book of Common Prayer*.

Space limitations prohibit mention of more than a few points concerning the remaining ten Baronets. However, their connection with local politics should not be omitted. The 4th Baronet was MP for Wycombe from 1796 to 1831. The 5th Baronet was MP for Buckinghamshire from 1832 to 1835, then MP for Wycombe from 1837 to 1862. So a Dashwood was MP for Wycombe for all but six of sixty-six years.

The wife of the 4th Baronet was rumoured to have had an affair with the Prince of Wales and the Baronet died alone and unhappy. He was a prominent magistrate in Aylesbury and Wycombe, and was very religious. He was a compassionate man who tried to secure a reduction in the number of executions, and was noted for visiting condemned prisoners.

Fishing, and hunting and shooting especially, feature prominently in the lives of several of the Dashwoods, and their first pack of hounds was established by the 4th Baronet. In 1823, during the tenure of the 5th Baronet, the estate's gamekeeper set a trap to catch poachers who he suspected were netting fish from the lake. A spring-loaded gun and a tripwire were set up. A loud bang was heard during the night, and the next day a notorious local poacher and another man were seen to be lame in the knees. They said that they had cut themselves with glass bottles. The setting of such traps was legal until 1826 and so was the setting of man-traps with spikes to grab an intruder's legs. This too was done on the estate.

Despite the wealth of the early Dashwoods, the later ones had to contend with financial difficulties, particularly the 8th and 9th Baronets. The family owned other estates, including a substantial one at Halton near Aylesbury, but the contents of Halton House were auctioned in 1849 and the house and estate were sold to Baron Lionel de Rothschild in 1853. The reduction of the family fortune did not stop the 9th Baronet being the Premier Baronet of the United Kingdom, which was probably why his son (the future 10th Baronet), then aged six, was a page at the coronation of Edward VII in 1902.

The story of the Dashwoods has, I hope, been interesting, but now for the remainder of the chapter, starting with St Lawrence's Church. A medieval place of worship stood on the site, but this was replaced with the present building by Sir Francis Dashwood, 2nd Baronet,

in 1752. It was and is a Church of England place of worship. Sir Francis travelled very extensively in Italy and was a lover of all things Italian, and the interior of the church contains beautiful frescoes by Italian artists. The most impressive painting is on the chancel ceiling and is by Giovanni Borgnis.

The church is at the top of West Wycombe Hill, which is managed by the National Trust and peaks at the highest point in the southern Chilterns. The tower is 260 feet high and there are 100 steps to the viewing platform at the top. As can be imagined the views from the top of the tower are stunning. The golden ball is above the tower and is eight feet in diameter. It can seat six people and was once open to the public, but this is no longer the case. It has a wooden frame, which is covered in gold leaf. The structure is believed to be based on the Customs House in Venice.

The Dashwood Mausoleum is adjacent to the church, and is a large, tall, unroofed, hexagonal structure, formed by a series of linked triumphal arches. It was built for Sir Francis Dashwood, 2nd Baronet, and was finished in 1765. It is still owned by the Dashwood family. In the centre is a cenotaph dedicated to Sarah, Baroness le Despencer, the wife of Sir Francis, who died in 1769. Perhaps the finest of the monuments, it is in variegated marbles with mourning cherubs.

One urn in particular has an extraordinary story. It is dedicated to the poet Paul Whitehead, who was a steward of the Hellfire Club and who died in 1774. His bequest to Sir Francis (who was also Lord le Despencer) read: 'I give to the Right Hon. Lord Despencer my heart as aforesaid together with £50 to be laid out in the purchase of a marble urn in which I desire may be deposited and placed, if his Lordship pleases, in some corner of the Mausoleum as a memorial of his warm attachment to the noble founder.' It came to pass and the installation was a great occasion. The ceremony included soldiers, a choir and musical instruments. Guns were fired from a frigate moored on the lake in the estate below. The whole thing lasted two hours. Sadly, the heart was stolen in 1829.

The mausoleum has contained the busts and commemorative urns of many members of the Dashwood family, and also of some friends and notable people. Many have been removed and, sad to say, some have been stolen.

West Wycombe Park was given to the National Trust by Sir John, the 10th Baronet, in 1943. His son, another Sir Francis, dedicated himself to a programme of restoration in association with the Trust.

The Park came into the ownership of the Dashwood family in 1698, nine years before the first Sir Francis was made a Baronet. He demolished the existing building and had a new one built on higher ground. His son, the second Sir Francis, inspired by his youthful travels in Italy, converted it into the Palladian style villa that can be seen today. Despite all his other activities and accomplishments he looked on this and his transformation of the estate as his life's work. The 12th Baronet and his family still live in the house, which is Grade I listed.

The eight ground floor state rooms are open to the public, and they contain many notable pictures, features and other things that cannot help but be of interest. Perhaps the finest of them all is the ceiling of the Music Room, which is a copy of Raphael's *Banquet of the Gods*. This is the largest of the rooms and it opens onto the East Portico. It most definitely cannot be guaranteed, but during my visit, which was on a pleasant sunny day, a choir was giving a performance. Visitors were enjoying it inside the room and also from outside the open doors.

West Wycombe Park is set in exceptionally beautiful, rolling countryside and a visitor is likely to experience a feeling of tranquillity. I did, anyway. Like the other things described, it owes much to the vision of Sir Francis, the 2nd Baronet, though later generations of the

family have modified it. A notable addition is the Water Garden. This was put in by the 11th Baronet (yet another Sir Francis) and it was dedicated to his second wife, Marcella.

All good parks should have a lake and this one does. It has three islands and is fed by an attractive water cascade. The water cascading over it is noted for being crystal clear, the reason being that it is fed by chalk streams.

The Park contains a number of temples, something that it has in common with the grounds at Stowe near Buckingham. There are seven of them, plus the Britannia Pillar and other features. Ranking the temples is a matter of individual preference, but my favourite is the Temple of the Winds. This dates from the 1750s and is a flint-faced octagonal tower with an ice house in the basement. It was inspired by the classical Tower of the Winds in Athens. The most notorious of the temples is the Temple of Venus, which stands on a small mound and takes the form of a rotunda enclosing a copy of the Venus de Milo. There is another very interesting feature, but my inherent modesty and regard for readers' susceptibilities prevent me from describing it.

At last, the Hellfire caves and Hellfire Society. For a very long time there had been an open-cast quarry on the side of West Wycombe Hill, its purpose being to dig out chalk for the foundations of houses in West Wycombe village. Sir Francis, the 2nd Baronet, set about extending this underground. The work finished as a long winding tunnel extending a quarter of a mile into the hill, with many chambers and divided passages leading off it and a huge room halfway down.

Sir Francis had two admirably altruistic motives and possibly two others. First of all there was serious local hardship and unemployment following disastrous harvests in 1748, 1749 and 1750. The tunnelling provided work with a wage of a shilling a day for unemployed local men. It was not much of a wage but the money was desperately needed. The second motive was to obtain material for the construction of a new straight road from Wycombe to West Wycombe. The old road was so deeply rutted that carriages sometimes overturned, especially in wet weather.

In addition, the project was probably an exercise in one-upmanship. Sir Francis could have obtained the chalk by expanding the existing quarry, but it is very possible that he wanted to impress his contemporaries and rivals. Lord Temple at Stowe was one such. They were engaged in grand projects including houses, estates, lakes, monuments, temples, follies and so on, but none of them had built lengthy underground tunnels. Another possibility, perhaps a remote one, is that Sir Francis envisaged holding meetings of the Hellfire Society in them. It is not certain that in the latter days of the club some meetings were held in the caves, but they probably were.

Reports of the activities of the Hellfire Society should be approached with great caution. Accounts of mass orgies and the like are often greatly exaggerated, and do not believe that the members engaged in devil worship. This is not true. Sir Francis was a Christian; admittedly one whose behaviour is not readily associated with the faith, but nevertheless a Christian believer. Earlier in this chapter it was mentioned that he played a significant part in the revision of the *Book of Common Prayer*. It is true, however, that members indulged in drunkenness and fornication.

The Society, with the motto '*Libertati Amicaticiaeque Sac*' (Sacred to Liberty and Friendship), met at the ruins of Medmenham Abbey, which is on the banks of the River Thames, 6 miles from West Wycombe. Meetings were held twice a year and members wore costumes. They featured dining and drinking, often a great deal of the latter, and (to put it delicately) amorous encounters with women who were not the wives of the members. The list of members was distinguished and included Sir Francis and his brother, the son of the

Archbishop of Canterbury, William Hogarth the painter, Lord Sandwich the notable First Lord of the Admiralty, John Wilkes and several other MPs.

After the Second World War the son of the 10th Baronet wanted to open the caves for visitors. His father thought that it was a crazy idea, but he leased the caves to his son for a payment of £1 a year. The son, who became Sir Francis, the 11th Baronet, in 1966, had very little money and what he could do was limited. The caves were in a bad state and fallen boulders of chalk were a problem. In some cases the caves were in a dangerous state. Nevertheless, with restricted access to visitors in some places, the caves were opened in 1951. The charge was 1*s* per person and this included the provision of free candles as there was no lighting.

A local vicar preached a sermon denouncing the evil influence that emanated from the caves. This was widely reported and was excellent publicity. It generated a lot of interest. The venture was a success and a few years later the future Sir Francis inherited some money and used part of it to transform the caves, which were improved and made safe throughout. Other enhancements included the installation of electric lighting, sound effects and waxworks.

I paid a visit to the caves as part of my preparation for writing this chapter, and I did so with few expectations of enjoying the experience. This was because a friend had warned me that I would be disappointed. He was wrong. I had a great time and it appeared that the other visitors did as well. It takes quite a while to walk to the end of the tunnel and back, plus the little detours and looking at the figures. There is also interesting material to read inside and a café outside.

Benjamin Franklin, one of the founding fathers of the United States, was a remarkable man and he had many achievements outside politics. The great statesman was a friend of Sir Francis, the 2nd Baronet. As such he was sometimes a guest at meetings of the Hellfire Club. The following is shown on one of the walls inside the Hellfire Caves. It is Franklin's reply to a young man who asked for his advice on the matter of taking a mistress:

> You should prefer old women to young ones. Because they have more knowledge of the world and their minds are better stored with observations, their conversation is more improving and more lastingly agreeable ... Because there is no hazard of children ... Because through more experience they are more prudent and discreet in conducting an intrigue ... Because in every animal that walks upright, the deficiency of the fluids that fill the muscles appear first in the highest part. The face first grows lank and wrinkled; then the neck; then the breasts and arms; the lower parts continuing to last as plump as ever; so that covering all above with a basket, and regarding only what is below the girdle, it is impossible of two women to know an old one from a young one ... Because the sin is less. The debauching a virgin may be her ruin and make her for life unhappy ... Because the compunction is less. The having made a young girl miserable may give you frequent bitter reflection; none of which can attend the making an old woman happy ... and lastly, they are so grateful. This much for my paradox. But still I advise you to marry directly.

I have read quite a lot about Franklin, but I had not come across this before. It was a bonus to an enjoyable visit.

At the time of visiting the Hellfire Caves are open every day from 1 April to 31 October. The grounds at West Wycombe Park are open from early April to late August. The house is open from early June to late August.

St Lawrence's Church is open to the public from 12.30 p.m. to 5.00 p.m. every Sunday from Easter Sunday to the end of September. There is a charge of £2.00 to climb the tower.

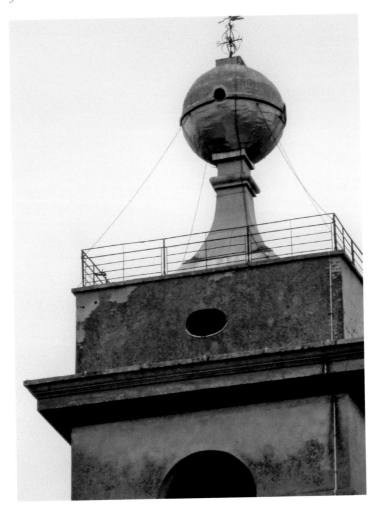

The golden ball
on top of
St Lawrence's Church.

Bradenham Manor and the Bradenham Estate

Bradenham Manor is on the right side of the train, 1½ miles beyond St Lawrence's Church at West Wycombe. It can best be seen by looking slightly backwards from an embankment, and it is necessary to look over some fields and a road, which runs parallel to the track. The Manor faces the line and is part-way up a hillside. It is a red brick building and is Grade II listed. The house is surrounded by large gardens. The estate and the manor house were taken over by the National Trust in 1956. It is now used as a training centre by the accountants Grant Thornton UK LLP.

Bradenham is mentioned in the 1086 Domesday Book. However, it did not take up much space because only two households were recorded.

In the thirteenth century the area was owned by the Earl of Warwick, and in 1505 it was sold to Andrew Windsor, who was knighted at Henry VIII's coronation. It stayed in the Windsor family for 140 years and the 2nd Lord Windsor built Bradenham Manor in 1550. He presumably did a good job because Elizabeth I stayed there in 1556. The present building incorporates some parts of the old one and was built in 1670 by Sir Edmund Pye. After this the building passed through several hands and in 1829 it was leased to Isaac D'Israeli, who lived there until his death in 1848. He was the father of Benjamin Disraeli. There is more about this shortly.

Isaac D'Israeli was a writer, scholar and man of letters. He had a distinguished career, but inevitably is best known for being the father of Benjamin Disraeli. Isaac was, as his name suggests, Jewish, but he conducted an eight-year dispute with the Bevis Marks Synagogue. As a result, in 1817 he had all his children, including thirteen-year-old Benjamin, baptised into the Church of England. Had he not done this Benjamin could not have been an MP, because until 1858 elected candidates could not take their seats until they had sworn a Christian oath. Of course, Benjamin could have later converted without reference to his father.

Benjamin Disraeli was twenty-five when his father leased Bradenham Manor and he spent a significant amount of time in the building. He was a novelist as well as a politician and parts of his novels *Sybil* and *Coningsby* were written there. His last novel, *Endymion*, published in 1880 when he was seventy-six, incorporated references to the house as he had known it in the 1830s. He gave it the name 'Hurstley' and refers to 'once stately grounds and glade-like terraces of yew trees, which give an air of dignity to a neglected scene'.

During his time at Bradenham, Disraeli acquired a love of the area. In 1848 he bought nearby Hughenden Manor and he is buried at St Michael and All Angels Church in Hughenden. He was MP for Buckinghamshire and in 1876 he took the title Earl of Beaconsfield. He was an extraordinary man and had an extraordinary career. Among other things he was Chancellor of the Exchequer three times and was Prime Minister twice. It is tempting to write many pages about him. That would not be appropriate, but the following are two examples of his wit.

An MP told Disraeli that he would die either by hanging or by some vile disease. He replied: 'That depends Sir, upon whether I embrace your principles or your mistress.'

Disraeli was Queen Victoria's favourite Prime Minister, not least because he flattered her outrageously. In 1880 she sent him a Valentine card. When he was dying she wanted to visit him. He said: 'No it is better not. She would only ask me to take a message to Albert.' This was Victoria's late husband, the Prince Consort, who had died in 1861. Her excessive mourning had been a national problem.

Bradenham Manor lies within the Bradenham Estate. In the 1950s this was acquired by the philanthropist Earnest Cook, the grandson of Thomas Cook, who founded the eponymous travel company. In 1956 the whole estate was given by the Earnest Cook Trust to the National Trust. We all have good reason to be grateful to Mr Cook, the Earnest Cook Trust and the National Trust.

The estate, which comprises 1,111 acres, contains an eighteenth-century cluster of brick and flint cottages, which are focused on the village green. The area around the village green is a designated conservation area and it contains no fewer than eighteen listed buildings. Areas of farmland and beautiful woodlands, primarily beech, lie within the 1,111 acres. They provide opportunities for pleasant and enjoyable walks. Close to the manor house are a cricket ground and a historic church, which can be seen from the train.

The cricket ground slopes slightly and is on the railway side of the manor house. Cricket has been played there since the 1860s, which makes it one of the country's older cricket grounds. To put this into context, the first test match against Australia was played in 1877. Australia won, which, despite some memorable English successes, became something of a habit. I have pleasant childhood memories of watching cricket at Bradenham in the company of my grandfather. In his youth and early middle age he had played for a nearby cricket club. He was totally ambidextrous and would sometimes bowl alternate overs right handed and left handed. He fondly hoped that I would follow in his sporting footsteps, but I let him down in this regard.

The Grade II listed Church of St Botolph is the oldest building in the village and stands next to the manor house. The nave and southern doorway date from 1100 and most of the building dates from the fourteenth century onwards. It contains a tablet memorial to Isaac D'Israeli and his wife Maria, both of whom are buried there. The medieval tower contains two of the oldest bells in England. They were cast in about 1300. The lychgate was erected 'in honour of those of this parish who gave their lives in the Great War'. The parish registers date back to 1627 and a particularly interesting entry in 1764 refers to the effect on the village of an earthquake centred in Oxfordshire.

If you ever visit the Bradenham Estate, prepare for a feeling of stepping back in time.

Bradenham Manor.

Red Kites

During the section of the line from the golden ball on St Lawrence's Church along to Princes Risborough it is worth looking for red kites. I periodically visit the area and have often seen them. They are magnificent birds and it is encouraging to dwell on the story of their reintroduction.

They are large, having a length of slightly more than 2 feet and a wingspan of up to nearly 6 feet. They frequently twist and turn in soaring flight. They have pale grey heads and warm orange or russet coloured feathers on the body and upper tail. The wings have black patches at the tips, and there are white patches under the tail and the wings. They have piercing yellow eyes and a particularly striking feature is the deeply forked tails. All of this can be clearly seen in the photograph accompanying this chapter.

Red kites are raptors. They feed on small mammals such as mice, voles, shrews, young hares, rabbits and small birds. Carrion and earthworms are important parts of their diet. They build nests in a main fork or high limb of a tree. When a predator is near the mother bird will warn the young, who will play dead. Red kites are monogamous and usually mate for life.

In the middle ages red kites were regarded as valuable scavengers because they helped keep the streets clean. According to the Royal Society for the Protection of Birds (RSPB), killing one was an offence that carried the death penalty, but there were hundreds of capital offences and one suspects that there were few if any executions for doing it. From the sixteenth century they were treated as vermin and a bounty was paid for killing them. For many years they were targeted by gamekeepers who wrongly thought that they took game, and they were also targeted by taxidermists and egg-collectors.

By 1871 red kites were extinct in England and by 1879 they were extinct in Scotland. Just a few were left in mid-Wales, the descent to the lowest number continuing until the 1930s. DNA analysis shows that the entire Welsh population is derived from a single breeding pair. Parallel declines and extinctions have taken place in other European countries.

A joint project by RSPB and English Nature (now Natural England) reintroduced red kites to several areas in England. Several of the initiatives succeeded and the most successful of all was in the Chilterns, encompassing the observation area mentioned in this chapter. Birds brought in from Spain and Sweden were released in the period from 1989 to 1994. Many of them prospered and they started breeding in 1992. There are now more than 1,000 breeding pairs in an area extending from Buckinghamshire into Oxfordshire, and since 1999 chicks have been taken and placed elsewhere in the country. The RSPB says that the UK population is now at around 1,800 breeding pairs, and there are juvenile and other non-breeding birds as well.

So successful has the project been that the birds are moving away from the Chilterns area. The first sighting of a red kite in London for 150 years was in 2006. I live in Leighton Buzzard, which is on the Bedfordshire/Buckinghamshire border. The lady who has typed this book (thank you Mary) lives nearby and she is a member of the Bedfordshire Bird Club. She has told me that she sees red kites almost daily and that one took a chicken leg that she put on her garage roof.

If you do look for the birds, you will be doing so from a good place. I hope that you are successful. Do not be put off by the words of William Shakespeare, who, in his play *King Lear*, described Goneril as a 'detested kite'. He also wrote: 'When the kite builds look to your lesser linen.' This is a reference to their habit in the nesting season of stealing clothes put out to dry.

A red kite.

The Clare Foundation Building

The Clare Foundation Building can easily be seen. It is on the right side of the train half a mile beyond Bradenham, and it is necessary to look over a road and a grassy area beyond it. The building is constructed of brick and, to me at least, has a pleasing appearance. A curved area in the middle and another curved area at one corner give it a distinctive appearance.

I have driven past the building numerous times, but until doing the research for this book I had never visited it. In the past I have seriously underestimated its size. It goes back a long way, which is not readily apparent from the railway or the road. The four sides of the building form an oblong, and it is one of the shorter sides that can be seen from the train. The enclosed area in the middle of the oblong is not roofed and is laid to grass. It is stretching the analogy to an absurd extent, but the whole thing puts me in mind of Doctor Who's TARDIS; it is much bigger inside than is apparent from the outside, and there is a large series of car parks at the back.

The complex covers 55,000 square feet and is located in 12 acres of rolling Chiltern countryside. The previous chapter gave an account of the introduction of red kites in the area, and they have most definitely established themselves in the vicinity of the building. During my visit I saw no fewer than four of them circling overhead. They were unmistakable.

The Clare Foundation is a charity that does not have a narrowly defined objective, such as the NSPCC for example. It works collaboratively with other voluntary sector organisations to assist them become more efficient and effective in all areas of their work.

The charity was set up as recently as 2010 and it bears the name of its founder, Mike Clare. He was Chairman until 2016, when he stepped down in favour of two co-chairmen: John Jeans, and the charity's former Chief Executive, Mike Elliott. Mike Clare remains a trustee. His story is a remarkable one. At the age of thirty he set up the bed and mattress retailer Dreams. He sold it just before the 2008 recession, and at the time it had 200 stores. As a seriously wealthy man he set up the Clare Foundation and moved his business career into property. He has other interests and in 2017 he served as High Sheriff of his native Buckinghamshire. One of the many things that the Clare Foundation does is to provide subsidised accommodation in the building that can be seen from the train. Another is to provide advisers who can provide help in areas where charities and not-for-profit organisations need specialist support. The building's facilities are offered commercially as a conference location, and for team building or away day purposes. It has a television studio and has been used as a film venue. It should also be mentioned that there is a bistro and a coffee shop.

To help charities and other not-for-profit organisations cut costs, raise money and in many ways become more efficient is not a common charitable objective. Clare advises on governance, a word likely to induce insomnia in many people, and it helps them run more professionally. The size of the operation indicates their success and the need for what they do.

The Clare Foundation Building.

The Grange

Mentioning a charity that trains and provides dogs to help physically challenged people is likely to provoke thoughts of the Guide Dogs for the Blind Association. This is natural because it is a large and well-known body that does what its name says. However, Hearing Dogs for Deaf People should not be overlooked. This too does what its name says, and its headquarters is located at the Grange. This building is close to the line on the right-hand side. It can clearly be seen a mile beyond Bradenham. The picture shows the café.

During my visit to the Grange I was given a warm welcome and much useful information, which did not come as a surprise. People who love dogs are likely to be friendly and helpful. What did surprise me was the size of the building and the number of people working in it. I had expected smaller and fewer. A visitor centre was in the course of construction and will be open by the time this book is published. It will encompass education facilities, a gift shop and a café, and it will welcome visitors throughout the year.

Hearing dogs are trained to alert the people with whom they are placed to respond to certain sounds. These include things such as alarm clocks, crying babies, doorbells and smoke alarms. This is the main and obvious thing that they do, but the organisation is keen to stress that they provide more benefits than this. Seriously deaf people sometimes suffer from a lack of confidence and independence and the dogs can provide a valuable boost to help alleviate these problems.

The Grange.

They breed the dogs that they train and place. Most of the parent dogs are labradors, spaniels, poodles, or are crossbred from these breeds. They are chosen for their good health, temperament and traits. Training methods are based on rewards and praise. Wrong behaviour and wrong responses are ignored and not punished. Punishment is considered to be counterproductive and not likely to make the dog get it right next time. A dog that is ignored is more likely to change its behaviour.

I have seen the dogs in action a number of times and it is a rather inspiring experience. They invariably appear to be enjoying what they are doing, something that is, I believe, common to nearly all working dogs. The hearing dogs can be distinguished by the burgundy coats that they wear. Knowledge of this hopefully enables members of the public to make suitable allowances for the people that accompany them, and it indicates to businesses and others that they should be admitted to places that otherwise do not allow dogs to enter.

The charity started its work in 1982 and it has progressively expanded since then. HRH the Princess Royal has been Patron since 1992. There are now more dogs than ever before. Figures can be tedious, but it is interesting to note that those most recently available report that there were 836 working dogs and ninety-five that have been retired. 145 dogs were placed in the year. 2,225 dog partnerships have been created since 1982. There are 134 full-time employees and fifty-three part-time ones. They are supported by 1,841 volunteers in a variety of roles, including fundraising and organising events.

It costs £40,000 to breed, train, place, and support a hearing dog throughout its life, so as with most charities money is important. In the last reported year, total income was £7.503 million. The surprisingly high (to me, at least) proportion of 63 per cent came from legacies, while 27 per cent came from donations and 8 per cent from fundraising events and trading. Donations and other support are gratefully received. Telephone contact is 01844 348 100 and the website is www.hearingdogs.org.uk.

Princes Risborough

The name Princes Risborough suggests that this small, very pleasant town probably has royal connections and a long and interesting history. It certainly does and more of this later. Of course Princes Risborough Station has no royal connections, but someone in a good mood and feeling generous just might call it bordering on pleasant. Be that as it may, in railway terms it does have a long and interesting history. The station is on the edge of the town, and is 2½ miles beyond the Hearing Dogs' headquarters at the Grange.

The first railway line to Princes Risborough was built by the Wycombe Railway Company and it ran from Maidenhead, where it connected with the route to Paddington Station in London. It was broad gauge and operated by the Great Western Railway. Princes Risborough Station opened on 1 August 1862 and shortly afterwards the line was extended to Thame, then on to Oxford. A further line was built by the same company from Princes Risborough to Aylesbury and this was opened on 1 October 1863.

A line from Princes Risborough to Watlington was opened in 1872. Then, in 1899, acting jointly with the Great Western Railway, the Great Central Railway opened up the new line into Marylebone Station in London. At its peak twenty-nine staff were based at the station and there were two operating signal boxes.

The contraction started in 1957 when the Watlington branch was closed to passengers. Then the route to Thame and Oxford closed in 1963. The present position is that there is one route southwards to London, and two northwards. One goes to Banbury and then on to Birmingham, which is the one described in this book. The other goes to Aylesbury. In 2015 a link at Bicester was opened and this allows trains to run from London Marylebone to Oxford via Princes Risborough.

This is not all, however. Steam trains run by the Chinnor & Princes Risborough Railway can sometimes be seen at the station. This is a heritage railway and operates a 3½-mile journey from Chinnor and the same distance back. This is on part of the Watlington branch that was closed to passengers in 1957. It is not yet possible for passengers to join or leave the train at Princes Risborough, but there are plans to allow this. I once enjoyed a most enjoyable cream tea on one of the trains and can recommend a trip.

This chapter's picture shows the Princes Risborough North Signal Box, which is Grade II listed and at the northern end of the station. It has the distinction of being the largest surviving Great Western signal box in the country. It closed in 1991, but it has been restored and maintained by the Chinnor and Princes Risborough Railway Association.

I have childhood memories of the station. This is because my family lived close to South Aylesbury Halt on the Princes Risborough to Aylesbury line. From time to time we travelled to London on it, changing to a through express at Princes Risborough. The evening return journey was sometimes made in the last coach of a slip train. This coach was detached from the speeding express at Princes Risborough and a second slip coach would be slipped off at Bicester. As can be imagined, as a young boy I found this enjoyable and fascinating. A friend was once on the slip coach when the brake was applied too vigorously and the coach stopped short of the station. An engine had to bring it in.

So much for the station – now for the town, starting with the royal connection. Before the Conquest in 1066 Risborough was held by King Harold. At the time of the Domesday Survey in 1086 it was listed as a royal manor held by the King (William I at that time). In 1344 Edward III granted it to his eldest son, Edward, Prince of Wales. He was known later as the Black Prince. He never became King because he died before his father. It was at this time that Risborough became known as Princes Risborough. After this, the manor was held by a succession of monarchs and members of their families. The royal connection continued until Charles I, who had debts at the time, sold it to the City of London. Not only did Charles lose Princes Risborough, he then lost his head twenty-one years later. To lose one or the other is understandable, but to lose both seems rather careless of him.

An attractive feature of the town is the Market House. The right to hold a weekly market and two yearly fairs was granted by Henry VIII in 1523.

The town has a number of places of worship. The two biggest are for Roman Catholics and members of the Church of England. The Roman Catholic Church of St Teresa was erected in 1937/38. It is brick-built and has a bulky, dominant appearance. It is topped with a dome, rather than a spire or tower. Whether or not its exterior appearance is pleasing is a matter of opinion. I wish all the best to the people inside, but my view is not favourable. St Mary's (Church of England) is very different, and in part very old.

St Mary's dates from the thirteenth century, but there was a small place of worship on the site before then. The church was enlarged and improved from the thirteenth to the fifteenth century, and significant parts of it date back to the 1200s. This means that they are nearly 800 years old, which should give us food for thought. How much of what we build now will be in use in the 2800s? The church was extensively restored and partly rebuilt in 1867/68.

Princes Risborough North Signal Box.

The tower, with a narrow spire above it, is particularly striking and can partly be seen from the train when it is in the station and just beyond. The original tower and spire were built in the fifteenth century. They fell down in 1803 and the fall damaged the church and destroyed a ring of bells. They were rebuilt in 1907/08 and, to coin a phrase, they are the jewel in the crown. I frequently pass through the town and I make a point of looking for the spire. It tends to put me in a good mood, or on a good day, an even better mood.

When describing old and beautiful churches it should not be forgotten that they have a modern purpose and are not there just to be looked at. This is of course also true of St Teresa's and others. St Mary's is very active and a random enquiry indicated a range of services and activities. They included a weekly men's curry night, which has to be good.

It is humbling to recognise that there are few villages and virtually no towns without a war memorial and perhaps other commemorations of sacrifices made for us. Princes Risborough is no exception and a poignant plaque outside the library honours the heroism of Clyde Cooper of the US Air Force. He lost his life steering his damaged plane away from the town in order to prevent damage and loss of life on the ground.

This chapter is about Princes Risborough, so inclusion of the Kop Hill Climb is slightly out of order. Nevertheless, it deserves a mention. Kop Hill is in the Chilterns just outside the town. The climb for motor vehicles was established in 1910 and during the early years famous competitors included Sir Malcolm Campbell, Sir Henry Seagrave, Raymond Mays and Archie Frazer-Nash. The fixture is held each September and attracts large crowds. Historic vehicles compete and others are on display.

The town is on the right side of the track and, as stated at the beginning of this chapter, it is small and very pleasant.

Whiteleaf Cross

Whiteleaf Cross is cut into the chalk escarpment of Whiteleaf Hill in the Chilterns. It is close to Princes Risborough and can be seen soon after Princes Risborough Station. It is on the right side and it is necessary to look slightly backwards to see it. The cross is 79 feet wide and 85 feet high, and it tops a base, which is 171 feet along its edge and 340 feet along the bottom. The whole thing is big and can be seen from a considerable distance. It is owned and maintained by Buckinghamshire County Council.

Across Britain there are many figures and symbols cut into chalk hills. Some of them were created relatively recently and their history and reason for existence are known. A well-known example is the Whipsnade Lion, which is cut into the Dunstable Downs. This was created in 1933 to mark the opening of Whipsnade Zoo. Others are older and some are much older. Their history and reasons for existence are often not known. Whiteleaf Cross is one of these.

The first written reference to the cross was made in 1742. Its history before then is a matter of little knowledge and a great deal of speculation. Theories include a Saxon celebration of a victory over the Danes, a phallic symbol later Christianised, a direction sign for a monastery, a seventeenth-century alternative to a village cross and soldiers in the Civil War amusing themselves. They all seem unlikely, and in particular it is hard to imagine it being an occupation of choice for soldiers.

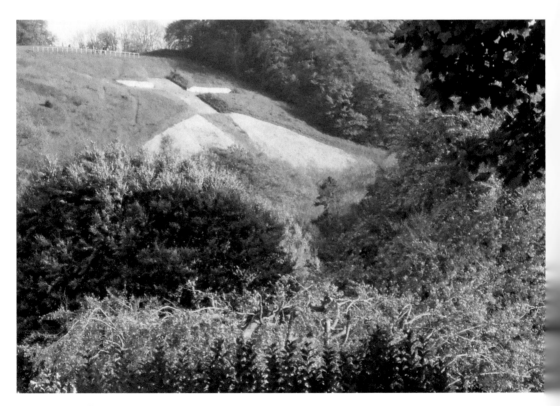

Whiteleaf Cross.

There is a Neolithic barrow near the top of the cross, which is interesting, but almost certainly has no connection with it. Also nearby are practice trenches from the First World War. It is a sobering thought that some of the soldiers who went over the top, and in many cases did not come back, did some of their training there.

Let us finish on a cheerful note. The cross, like many other figures and symbols cut into chalk, was covered up during the Second World War. This was to prevent them being a landmark that would help the German bombers find their targets. There was great local rejoicing on VE Day in 1945 when the brushwood covering the cross was removed.

Coombe Hill

The Chilterns are a range of hills running north-west of London, and three main line railway routes pass through gaps in them. The line described in this book is the most westerly and passes through at Princes Risborough. The line from London Marylebone to Aylesbury passes through at Wendover and the line from London Euston passes through beyond Wendover at Tring. Apart from these gaps the escarpment of the hills is almost continuous. Whiteleaf Hill and Whiteleaf Cross were the subject of the last chapter. Further north-eastwards are the prominent Beacon Hill and Coombe Hill, in that order. They are several miles away and jut out prominently.

Beacon Hill can be seen shortly after Whiteleaf Cross becomes visible, and it should be recognisable because of an isolated clump of windswept trees at the top. Coombe Hill is beyond it and should be recognisable due to a long slope down from a higher summit. It can be seen on and off from shortly after Princes Risborough to a mile or so before Haddenham & Thame Parkway Station.

The highest point in the Chilterns is at Haddington Hill, a few miles further away, but Coombe Hill, which peaks at 852 feet above sea level, is the highest readily accessible viewpoint. It covers 106 acres and was given to the National Trust by Lord and Lady Lee of Fareham. They did this in the early 1920s, at the same time that they gave the nearby Chequers Estate and house to the nation. The hill is a Site of Special Scientific Interest, and thirty species of wildflowers and twenty-eight species of butterflies flourish there.

A visit to Coombe Hill provides a glorious view over the Vale of Aylesbury. It looks down on Coombe Hill Golf Course and Butlers Cross Village, and close by are Beacon Hill and the Church of St Peter and St Paul in Ellesborough. It is interesting to have a close view of Beacon Hill from the side that cannot be seen from the train. There is a lot to be said about the church and an account is given at the end of this chapter.

At the top of Coombe Hill is a rectangular concrete pillar that is the trig point, and it is topped with a metal plaque that was donated in 1988. This points to true north and to the following distant features: the Cotswolds (53 miles); Brill Hill (13 miles); Waddesdon Manor (10 miles); Calvert Chimneys (15 miles); Mursley Water Tower (15 miles); Wingrave Church (8 miles); Leighton Buzzard (12 miles); and Ivinghoe Beacon (9 miles).

I have visited Coombe Hill many times and, with one possible exception, I have seen everything mentioned on the plaque. They are all interesting, but especially interesting, to me at least, are Waddesdon Manor and Mentmore Towers. The latter features in my book

Great Railway Journeys: London to Birmingham by Rail (also published by Amberley). It is a sister book to this one and covers the route from Euston Station in London, which passes through Watford, Milton Keynes, Rugby and Coventry.

The possible exception is the Cotswolds. 53 miles is a very long way, but it must be possible or it would not feature on the plaque. I have not yet done so, but I intend to do some calculations using trigonometry and the curvature of the earth's surface. To see the Cotswolds would need exceptionally clear visibility. I like to think that I have done it, but perhaps it is wishful thinking.

The most notable feature of Coombe Hill is the monument at the top, which is owned by Buckinghamshire County Council. It is located at the peak of the hill, just above the concrete pillar described above, and, like Whiteleaf Cross, it was camouflaged during the Second World War. This was to prevent it being a navigation aid for German bombers. It is tall, big and prominent, but short of using binoculars it may not be visible from the train. It is, however, shown in the photograph accompanying this chapter.

Until the Second Boer War of 1899–1902, war monuments almost always commemorated victories, but they did not list the names of the fallen. The Coombe Hill Monument is an early and splendid example of one that does do this. Interestingly, the plaque on it terms the conflict as 'The South African War'. It lists the 143 names of the men of Buckinghamshire who lost their lives fighting for queen and country (or king and country) in that conflict.

The monument was financed by public subscription and erected in 1904. It was unveiled on 4 November in that year. It was almost totally destroyed by lightning in 1938 and was rebuilt in the same year. In the early 1990s it was again damaged by lightning and again repaired. It is now protected by lightning conductors.

In 2010 the monument was rededicated after substantial restoration work. A new plaque corrected spelling errors on the original and added two names that had been omitted. The memorial was deep-cleaned, weathered joints were replaced, fresh gold leaf was applied to the filial, and the county crest and bronze flags above the plaque were restored.

Not all of the 143 men who died were killed in battle. As in the Crimea and other wars, disease took a severe toll. Research shows that many died in this way and the words 'enteric fever' appear quite a few times.

What follows in no way diminishes the sacrifice and patriotism of those killed (or of those who died from disease) and whose names appear on the monument. However, it is worth mentioning that the Boer War was very controversial. Many foreigners thought that Britain's cause was unjust and many Britons felt the same. Furthermore, in the early days of the war the British military performance was deplorable. Lloyd George led the opposition to the war and said it was like the British Empire fighting Caernarvonshire. He went on to say that Caernarvonshire was winning. In the latter part of the war the Boers were subdued by the use of so-called concentration camps.

It does not get a mention on the plaque at the top of Coombe Hill, probably because it is close by, but the Church of St Peter and St Paul at Ellesborough can be seen very clearly and is most definitely worth a mention. This is because it is a fine and interesting church, and also because of its association with Chequers and the Prime Ministers who have visited it. The church is at the summit of a hill just below Beacon Hill. I write with some authority because as a teenager I lived in Ellesborough Parish and regularly attended services there, and also because it was the place of my first marriage.

The church is now part of a benefice of five churches. I had to look up the word and found that it means a group of churches that are administered collectively. Regular services are held in it and there are other activities. Between Easter and the end of September

afternoon teas are served, and on these occasions it is usually possible to ascend the tower. The effort is rewarded with stunning views.

St Peter and St Paul's is of course Church of England and it dates back to the late fourteenth and early fifteenth century. It was restored and externally refaced between 1854 and 1871. The Reverend Cyril White was the minister for a very long time, including the period of my attendance, and he conducted my first marriage. He conducted numerous services attended by the great and the good – or the great at any rate. He was a kindly man who gave devoted service and I remember him with affection.

A plaque inside the church cannot help but move any thoughtful visitor. It is headed 'Roll of Honour – Ellesborough Parish', and it lists the names of the nineteen men of the parish who died in the First World War and the nine men who died in the Second World War. The name Flitney is listed four times for 1914–18, and the name Eldridge is listed twice for 1914–18 and twice for 1939–45. The thought of wives, mothers and others looking with dread at the approach of a telegraph boy brings tears to one's eyes. It did to mine, anyway.

The population of Ellesborough is currently fewer than a thousand, and it would have been less during the wars. Let us assume that it was 700. Take off an estimated 380 for women and girls and we are left with 320. Let us then take off boys and men who were not of military age and we are left with 100. Let us assume that a further thirty did not fight because they were unfit, in reserved occupations, were conscientious objectors or for some other reason. We are left with perhaps seventy fighting men. Then let us work out the ratio of men killed to the number of men serving. You can do the calculations and you can substitute your own figures if you doubt the ones given. Finally, do not forget that only the names of the men who died are given. The names of those who were wounded and survived are not. Not many enlisted men from the Parish of Ellesborough returned unscathed.

Chequers cannot be seen from Coombe Hill, but it is close to the church, at the opposite side of Beacon Hill. In a stunning act of generosity Lord and Lady Lee of Fareham gave Chequers Estate and the house to the nation in 1921. A stained glass window in the long gallery of the house bears the inscription: 'This house of peace and ancient memories was given to England as a thank-offering for her deliverance in the great war of 1914-1918 as a place of rest and recreation for her Prime Ministers for ever.'

The house and estate are splendid and the house contains many fine books, pictures and treasures. A diary of Admiral Lord Nelson is one of them. The house and estate are not open to the public; rather, they are for the use of the Prime Minister and are intended to provide a place for him or her to relax. Prime Ministers do relax there, but of course they work and entertain as well.

David Lloyd George was Prime Minister in 1921 when the gift was made and he was the first of them to use it. I believe that since then all Prime Ministers have done so, some a little and some a lot, and I believe that almost all of them have visited Ellesborough Church. A particular poignant memory is of Margaret Thatcher standing outside of the church in October 1984, saying: 'This is the day that I was not meant to see.' It was just a few days after she survived the Brighton bomb, which was an assassination attempt by the Provisional IRA.

I well recall Harold Macmillan attending the church in the late 1950s and early 1960s, sometimes alone and sometimes accompanied. He would often read one of the lessons in a most melancholy manner. Things were rather different in those days and there was little apparent security, though there was some. A typical service would be attended by about fifty villagers (including me), Harold Macmillan and one or two cabinet ministers or perhaps a visiting Prime Minister.

The Coombe Hill Monument.

On one occasion at least six Prime Ministers from Commonwealth countries came. They were attending the Commonwealth Prime Ministers' Conference. Afterwards Harold Macmillan and John Diefenbaker of Canada walked back to Chequers across the fields. As I remember it they walked completely alone with no accompanying security, though possibly my memory is at fault. President Eisenhower of the United States also once attended a service. The Reverend Cyril White served at Ellesborough for more than thirty years and he preached to some very famous people.

St Mary's Church, Haddenham

Most of us know, perhaps to our cost, that information on the internet cannot always be relied upon to be absolutely factual. This chapter starts with an example. An internet search revealed that St Mary's Church, Haddenham, is a world heritage site. After a few moments' excitement, caution prompted me to check this. There are only thirty-one properly designated world heritage sites in the United Kingdom and, not surprisingly, Haddenham Parish Church is not one of them. The list includes such gems as Stonehenge, Blenheim Palace and the Tower of London. St Mary's is, however, a listed building, old, picturesque, interesting and inspiring.

The church, which is Anglican and the Parish Church of Haddenham, is on the right side of the train, 5 miles beyond Princes Risborough and three quarters of a mile before Haddenham & Thame Parkway Station. Much of the tower and rear of the building can be seen from the train. The photograph shows the front of the church, together with part of the village green and the large duck pond.

It is an exceptionally beautiful scene, which is sometimes used in films and television series. Prominent examples include a number of appearances in the long-running and much-loved television series *Midsomer Murders*. This is set in a series of quaint villages and at the time of writing series twenty is in the course of production. The first nineteen series have contained a total of 116 episodes. The number of murders per episode averages around three, and there are also suicides and natural deaths. The murder methods are frequently bizarre. It appears that the life expectancy of the Midsomer residents is not dissimilar to that of soldiers fighting at the Somme in 1916.

A church stood on the site of the present building before the Norman Conquest. It is known that in 1086, twenty years after the Conquest, Haddenham was held by Lanfranc, the Archbishop of Canterbury. It is also known that at this time the priest was named Gilbert. Parts of the church are twelfth-century Norman, but the church as we know it today was built during the thirteenth century. However, the font and certain parts may be from the original Saxon church. The tower is early English Gothic.

A mass of detail about the features of the church is available but it would be tedious for many readers to reproduce it here. It is, though, interesting to note that there are two fonts, one in normal use in the church and the other in use as a planter outside.

On entering the church I noticed that it was spotless and well maintained, and I felt a sense that it had stood as a place of worship for many centuries. I also felt that our generation, even if not very religious, has a duty to keep it going for the benefit of our descendants. This respect for its age and continuity was reinforced by a board that listed

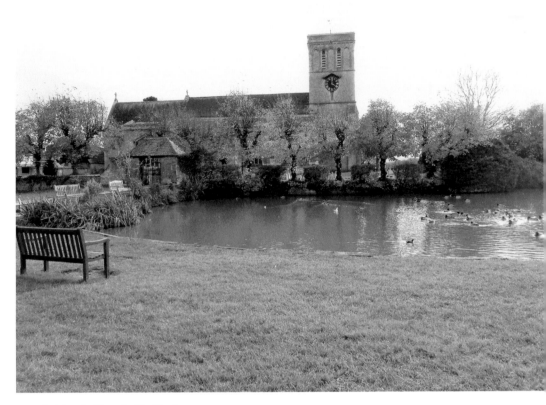

St Mary's Church, Haddenham.

all the vicars since 1312, more than 700 years ago. Two of them had served for no fewer than forty-three years – Frances Colston from 1689 to 1732 and Henry Meeres from 1855 to 1898.

The long list of vicars contains the name of only one woman, the present (at the time of writing) incumbent. This is Margaret R. Hodson, who took the position in 2009. It is as recent as 1994 that the first women priests were appointed in the Church of England, and the number of them is now very considerable. Where would the Church of England be without them? To answer my own question, its problems would be greater than they already are. Like most Christian churches it suffers from too few people coming forward for the ministry. It is also significant that nine of the twelve people holding other important positions in St Mary's are women. The twelve names and details of their appointments are shown inside the church.

The tragedy of war is evident both within the building and outside. The village war memorial is on the village green and lists the names of the fifty-nine men of the village who died in the world wars. One of the church's stained glass windows is inscribed: 'To the Glory of God and in grateful memory of David Rowlandson Major Royal Horse Artillery Born 1st November 1916: Killed in Action in Sicily 13 July 1945.' The inscription goes on to commemorate the lives of his mother and father, the latter of whom was Church Warden for a number of years.

Not long ago most churches were routinely left unlocked for much of the time. Strangers were welcome to walk in, perhaps for religious reasons, or just to rest or look round. Regrettably, and for understandable reasons, this is often not the case. I was delighted that St Mary's was unlocked when I arrived. It was mid-morning on a weekday. Although I would have been pleased to meet people, I was the only person there. The church was otherwise empty and I could see at a glance that some of the contents had some value. After a while a lady arrived and I asked her if they had suffered from vandalism or theft. She told me that they had, but that they thought it important that the church be left open for much of the time.

Haddenham and Thame

Haddenham is a large village just on the Buckinghamshire side of the county border with Oxfordshire. Thame is a small town 2 miles away, just over the border. Both places are served by Haddenham & Thame Parkway Station, which is on the western edge of Haddenham. This is 6 miles beyond Princes Risborough and a short distance beyond St Mary's Church, which is the subject of the previous chapter.

At one time Haddenham and Thame had separate stations, which were on separate lines. Thame Station opened in 1862 and was at that time the terminus of an extension of the High Wycombe Railway. In 1864 this line was extended from Thame to Oxford. Haddenham Station was on a line constructed north of Princes Risborough for the Great Central & Great Western Joint Railway. This opened for goods in 1905 and for passengers in 1906 and Haddenham Station was built for it. Both stations were closed in 1963 as part of the extensive (and now generally regretted) railway cutbacks around that time.

Haddenham & Thame Parkway Station was opened by British Rail in 1987. In 1998 Chiltern Railways doubled the track between Princes Risborough and Bicester and remodelled the platforms. Later the platforms were lengthened and there were major renovations in 2014/15. It is a modern, pleasant station with a modern, pleasant coffee shop. What is more, during my two visits I found modern and pleasant staff, as in my experience is the case at most stations. On my first visit I walked on to a platform to take the photograph that accompanies this chapter, and for security reasons I was asked what I was doing. When I explained the two people asking the question wished me success with the book and offered me a sweet.

It is a busy station. An indication of this is the large car park, which is partially covered by an upper tier. During my first visit it was absolutely full and drivers were looking for spaces without success. During my second visit there were only a handful of spaces left. This is a problem in many stations, not least in my home town of Leighton Buzzard. Housebuilding in both Haddenham and Thame is going to make the problem worse.

The 1086 Domesday Book records the manor of Haddenham as Hedreham. A record of 1142 refers to it as Hedrenham. From the Norman Conquest of 1066 until the Dissolution of the Monasteries in the reign of Henry VIII the Manor of Haddenham, as we will now call it, was held by the Convent of St Andrew in Rochester. After the Dissolution of the Monasteries it was held by the Crown, and on the death of Henry it passed to his daughter Elizabeth, who was to become the first Queen Elizabeth.

For most of Haddenham's existence agriculture was the almost exclusive source of employment. Due mainly to the reduction in the number of agricultural jobs in the area, the village's population declined from about 1850, and it was a hundred years until it regained the 1850 level. Since then it has expanded very considerably and the 2011 census put it at 4,052. It has increased further since then and continues to do so. It is stretching the analogy to an absurd extent, but well-educated people who regret the increasing number of villagers might recall a resolution passed in the House of Commons in 1780. This was: 'That the influence of the Crown has increased, is increasing and ought to diminish.' The monarch at the time was George III and the vote was 233 to 215. The number of houses has increased and is increasing, and some would say should not increase any more.

A civilian airport was opened at Haddenham in 1939, just before the start of the Second World War. The military took it over and for a while No. 1 Glider Training School was based there. Flying did not resume afterwards but factories were built on the site. The area is now an industrial estate.

A train pulling in to Haddenham & Thame Parkway Station.

The village contains a number of ponds, including the one outside St Mary's Church mentioned in the last chapter. The famous Aylesbury ducks have been bred there. The village is noted for the 'wychert' method of building some of its properties. Wychert is a way of building with white clay mixed with straw to make walls and buildings, which are then thatched or topped with red clay tiles.

A few enquiries and just a little research are enough to show that Haddenham is a vibrant village with many events and activities going on.

According to the 2011 census Thame had a population of 11,561. The town takes its name from the River Thame, which flows nearby and is a tributary of the Thames. Since 1953 an annual tug of war has been held between the nearby villages of Ickford (in Buckinghamshire) and Tiddington (in Oxfordshire). The two teams stand on different sides of the river and try to pull their opponents into the water. The event was originally just for men, but it now also features teams of women and juniors. A good time is had by all, or nearly all.

Thame is a pleasant market town with attractive buildings and an extremely wide High Street. The Bird Cage is an old and prominent public house. It is interesting for a number of reasons, one of them being that during the Napoleonic Wars it was used to hold sixteen prisoners of war. A ball and chain have been found within it.

The annual Oxfordshire County and Thame Show is held next to the town and is said to be the largest one-day agricultural show in the country. St Mary's Church in Thame deserves a mention, but St Mary's Church in Haddenham had the whole of the previous chapter. So even though much could be said about it, with reluctance it will not be. Instead this chapter ends with an account of John Hampden.

'No taxation without representation' is a phrase associated with John Hampden. He refused to pay the Ship Money Tax on his lands in Buckinghamshire and Oxfordshire. This was introduced by Charles I without the consent of Parliament. Hampden attended the grammar school in Thame and became an MP. He fought on the side of Parliament in the English Civil War and was mortally wounded at the Battle of Chalgrave in 1643. He died in Thame shortly afterwards.

Bicester

The town of Bicester is the next place of note following Haddenham and Thame. It has two stations, with the line from London to Birmingham passing through Bicester North. The other station is Bicester Village, which is on the line to Oxford. A shuttle bus service runs from Bicester North Station to Bicester Village.

Bicester Village Station has a long history and has had several names. It was opened with the name 'Bicester' in 1850, and was renamed 'Bicester London Road' in 1954. The station was closed in 1968 along with the Oxford to Bletchley section of the Varsity Line from Oxford to Cambridge. It was reopened as the terminus of the Oxford to Bicester line in 1987, and at this time it was given the name 'Bicester Town'. It was renamed again in 2015, this time being given its present name of 'Bicester Village'. This reputedly annoyed some local people, who felt that there had not been proper consultation.

As its name suggests, Bicester Village Station serves the large, prestigious and successful shopping centre with that name. Trains to Bicester Village are advertised at London Marylebone and the quickest takes forty-six minutes. Although some people come by train, most come by car or coach. There is a very large car park and at times significant traffic congestion. At the name of Bicester, many people automatically think of Bicester Village.

Bicester Village is home to more than 160 fashion and lifestyle boutiques. Many of them are very upmarket, selling luxury brands. They are said to offer big discounts, but having had a look at some of the shops and their prices I am left wondering what the undiscounted prices must have been.

I noticed that several of the shops, Gucci being a prominent example, had people queuing outside and only let a few people in at a time. I could not help wondering if this was a marketing ploy. It is something that Hard Rock Café used to do, and perhaps still does. Even at 9.30 in the morning and with the café almost empty there would be a queue outside. It made it look busy and successful, though it did not have that effect on me.

Bicester Village was opened in 1995 and it has grown enormously since then. The shops and the environment seem clean, modern and enticing. Judging by the number of people there when I visited, a lot of people had been successfully enticed. They were predominantly women and generally seemed to be very happy. The photograph accompanying this chapter

The writer photographed at Bicester Village.

shows me sitting on a sleigh in Bicester Village. I look as though I was enjoying my visit, as indeed I was.

Bicester Airfield covers 348 acres and is located at the edge of the town. It has an interesting history and things happening there now are worth more than a passing mention. Spasmodic flying took place there before the First World War, and it became a military base in 1916 when a training depot was established. In 1917 the Royal Flying Corps established No. 118 Night Bomber Squadron there. At the end of the war No. 44 Training Station Depot was at Bicester, and in 1919 Bristol Fighters returned from France were based there. The airfield was briefly used as a clearing centre for repatriated soldiers, and then in 1920 it was closed.

Redevelopment work started in 1925 and by 1928 various RAF bombers were operating from the airfield. During the Second World War Bicester was used for training, but there were no operational flights. Sadly, there were two fatal crashes within four days in 1940 and a further one in 1941.

After the Second World War the airfield had a number of military functions, but the RAF ceased to use it in 1976. Windrushers Gliding Club started operating at the airfield in 1953 and have continued there ever since. They enjoy gliding, train prospective gliders and welcome enquiries. The departure of the RAF could have resulted in the site of the airfield being developed for housing, but a proposal to do this was defeated. Instead there have been innovative and exciting developments in recent years.

The airfield is now home to Bicester Heritage. Its website says: 'At its heart Bicester Heritage has a vision to secure a robust and dynamic future for motoring past, present and future.' It also says that they have established the first business campus dedicated to historic motoring. Airfield buildings have been restored, including the control tower, and there are fifty of them, nineteen of which are Grade II listed.

There are more than thirty companies specialising in the restoration of historic motor vehicles and aircraft. Classic car auctions are held from time to time. Tiger Moth flights can be arranged and it is the home of the Bicester Gliding Centre (formerly Windrushers Gliding Club). There is a test track and classic car driving experiences can be arranged. Events open to the public are periodically held.

Bicester's origins date back to Saxon times. The Domesday Book of 1086 called it Berencestra and it acquired its present name in the seventeenth century. Perceptions may differ but until relatively recently many might have called it a rather sleepy market town, pleasant in at least some parts. This is no longer the case. Apart from anything else, the development of Bicester Village has changed the character of the town. The population has almost doubled in the last thirty years and is currently in excess of 31,000. It will probably increase by a lot more.

Bicester was designated the UK's first Garden Town in December 2014. Cherwell District Council says that the decision was shaped by Bicester's attractive greenery and facilities, and by its people, heritage and natural environment. Garden Town status brings government funding to enable the people of the town to be actively involved in planning what will happen. It is possible that this will result in 13,000 new houses and 21,500 new jobs, together with (hopefully) the necessary supporting infrastructure and green spaces.

Reasonable guesswork indicates that 13,000 new houses would likely almost double the present population of Bicester. Would it be paradise in North Oxfordshire? Perhaps! Many people do not think so and prefer the existing green fields. However, there would certainly be more people on the trains.

The Oxford Canal

The Oxford Canal joins the River Thames at Oxford and runs via Banbury and Rugby to Coventry. It links with the Grand Union Canal at the villages of Braunston and Napton-on-the Hill, and to the Coventry Canal at Hawkesbury Junction in Bedworth, which is just north of Coventry. It is 78 miles long, has forty-six locks and is a narrow canal. This means that the lock gates are single and that the maximum beam for boats is 6 feet 11 inches. Like most English canals it is generally both beautiful and peaceful, which helps to explain why it is popular with boaters, walkers and anglers.

The canal follows the line of the railway for a long way, though as the canal was built first we should perhaps say that the railway follows the line of the canal. The first sight of it is 8 miles beyond Bicester, where the canal can be seen on the left side of the line. The photograph is taken from a point shortly after there. After this it remains close to the track on the left side all the way to Banbury, and it can be seen in many places.

Both the railway and the canal pass through Banbury, then the line crosses the canal shortly after the town. After this it is on the right side of the train close to the track, and can again be seen in many places. This continues for a long way, past the village of Cropredy and on to a point close to Fenny Compton, where the canal swings off to the right. As well as being close to the railway, the canal is close to the River Cherwell. This is from 8 miles beyond Banbury through to Cropredy, north of Banbury. The River Cherwell is the subject of the next chapter in this book.

The Oxford Canal was conceived in the late 1760s but it was more than twenty years until it was completed. The reason for the delay was financial difficulties, something that hampered the building of some other canals and later some railways. The main justification for the canal was to link the Midlands with London, via the River Thames. Among other things this would allow coal to be brought to the capital.

The Oxford Canal Bill received Royal Assent in 1769. It had been presented to Parliament by Sir Roger Newdigate MP, who became chairman of the canal company. Construction commenced from the Coventry end and by 1774 the canal had reached Napton, but the company had almost run out of money. A second Act of Parliament was passed in 1775 and this enabled more capital to be raised. Banbury was reached in 1778, but once again there were money problems and work stopped.

It was not until 1786 that construction restarted and the canal reached Oxford in 1790. Due to the shortage of money economies were made on this last stage. Some of them were false economies and the effects are still with us now. One was utilising the River Cherwell as part of the canal. This saved money but the variable behaviour of the river made the canal harder to use.

For the first fifteen years after completion the Oxford Canal was a considerable commercial success. Then, in 1805, the Grand Junction Canal was opened. This was a more direct route from the Midlands to London and did not use the River Thames. This was quicker and more efficient, with the result that much of the traffic on the southern part of the Oxford Canal was lost. However, traffic from Birmingham had to use 5 miles of the Oxford Canal to get from Braunston to join the Grand Junction at Napton. The Oxford Canal was able to charge high tolls from Grand Junction traffic on this section. This, to some extent, alleviated the loss.

The northern part of the Oxford Canal remained busy with freight traffic until the 1960s, but the southern part suffered a massive decline. From the 1960s there was a renaissance due to the use of the canal by pleasure craft.

The canal was built using the contour method. This means that the route followed the contours, which reduced the need for locks. Another advantage was that the canal served more villages and wharves. The disadvantage was the increase in the length and journey times. In the 1830s Marc Brunel (father of Isambard Brunel) and William Cubitt straightened several of the loops in the northern part. This reduced the length of the canal by more than 14 miles and other improvements were made.

I have a nostalgic interest in a number of canals. This is because I walked the length of several of them in the company of my son, who at the time was a young teenager. We did the Oxford Canal together in 1988/89 and we kept a journal throughout, so I have a lot of material to jog my memory. What follows is up to date, but draws on our experiences and writing at the time.

The canal links with the River Thames in two places. One is 3 miles north of the city centre where Duke's Cut leads to King's Lock. The other is close to the city centre near Oxford Railway Station, through Sheepwash Channel and below Iris Lock. Until 1951 the canal continued further, but at that time the basin and wharves were filled in and Nuffield College now stands on part of the site. A very pleasing wildlife area adjoins the towpath out to the northern suburbs of Oxford. At the other end the canal joins the Coventry Canal at Hawkesbury Junction. A very attractive feature at this point is a cast iron bridge where the canals meet. This was erected for the Coventry Canal Company in 1837.

The Oxford Canal near Aynho.

Hawkesbury Lock links the Oxford Canal with the Coventry Canal and this has a fall of just 1 foot. The lock with the smallest fall is Aynho Weir Lock, which has a fall of less than 1 foot. This is located close to the place where the photograph was taken. Its primary purpose was to protect the canal from any surge in the River Cherwell, which crosses the canal nearby. The next lock on the Oxford side is Somerton Deep Lock, which has a fall of 12 feet 2 inches. Three flights of locks are all at the northern end. They are Kilmorton (nine locks), Napton (nine locks) and Claydon (five locks).

Between Bicester and Banbury the canal passes close to the village of Upper Heyford. It is now rather sleepy with a population, according to the 2011 census, of 1,295, but prior to 1994 this was very far from the case. The reason was that RAF Upper Heyford was closed down in that year. Despite being technically an RAF base, it was a large operational facility of the United States Air Force. A substantial contingent of service personnel lived there and worked nearby. I well remember the roar of overhead aircraft during the walk with my son in 1988.

In 1964 at the height of the Cold War I was part of a group of people entertained by Americans at the base. They were, like most Americans, very hospitable and among other things took us round the base on a coach. At that time there were always six planes in the air, six on the runway ready to take off at a moment's notice and six stood down. All the planes were armed with nuclear weapons. As we approached the six planes at the end of the runway we saw that they were guarded by two men with rifles. Our host warned us that if the coach stopped we should on no account get out. If we did, there was a real chance that we would be shot. They took guarding the planes and the nuclear bombs very seriously. Just as well, I suppose.

Banbury is the location of Tooley's Boatyard, which is the oldest working dry dock on the Inland Waterways. It has been in continuous use since 1790, when it was established to build and repair wooden horse-drawn boats. It contains a 200-year-old forge, which is in regular use. The blacksmiths make things to order and run courses for people who want to learn the craft.

It is appropriate to end this chapter by paying tribute to the pleasantness and tranquillity of the Oxford Canal, especially the southern part from Oxford to Banbury. It is very little spoiled and a journey along it is likely to put you in a good mood. Guide books frequently make this point, and having walked the length of it I concur. There is no substitute for a walk or a boat trip, but hopefully a look from the train will give a sense of it.

The River Cherwell

The River Cherwell is 40 miles long, and is a major and the most northerly tributary of the River Thames. It rises not far from Daventry in Northamptonshire, joins the Thames at Oxford and drains an area of 364 square miles.

The river is of interest because for some of the way it flows close to the railway line, but in the opposite direction to this journey. The proximity starts just after the photograph of the Oxford Canal shown in the last chapter. The river is on the left side of both the train and the canal, but after 1½ miles the line crosses them and they are then on the right side.

The canal is then closest to the train. The Cherwell cannot be seen in Banbury, but both the river and the canal, with the river furthest away, are close to the right side of the train for some miles afterwards.

The photograph is of an exceptionally interesting part of the river. It is not far from the point where the line becomes close to it, and three-quarters of a mile beyond the disused Aynho Station. It is necessary to look down on the left side from a bridge. The canal is running roughly parallel with the track and the river crosses it at right angles. Water overflows from the canal into the river on the far side over a weir.

The picture was taken on a murky day following a period of heavy rain and it shows the water below the weir. Sometimes there is little water going over it, but the photograph was taken following a downpour, and for this reason white water can be seen. The river is still comparatively narrow at this point and very different from the wide waterway near Oxford. The photograph was taken after a very muddy 1-mile walk along the canal towpath.

The arrangement of this area is uncommon in the British canal system. One reason is that a canal crossing a river in this way does not often happen. An aqueduct is much more usual. Another is the untypical lock on the river, just below the weir. The drop is a barely discernible 12 inches and it was therefore decided to make the chamber lozenge-shaped instead of the normal rectangle. This allows a larger volume of water to pass through than would otherwise be the case.

The Cherwell has never been navigable on any scale. It is believed that in the seventeenth century small, flat-bottomed boats took goods from Oxford to Banbury, and in 1764 coal was taken up the river as a test.

Shortly after the crossing described above, the Cherwell passes close to the village of King's Sutton, which is the subject of the chapter after next in this book, followed by Banbury. Like numerous towns, its location was influenced by the proximity of a river. 8 miles north of Banbury the river moves away towards the east and cannot afterwards be seen. This happens just before the village of Cropredy, where it runs through fields used by the annual Cropredy Festival. This is an annual three-day event run by the band Fairport Convention. I have been told that it regularly attracts 30,000 visitors.

Not many bridges over minor roads are named on maps, but Ordnance Survey gives this distinction to Cropredy Bridge, which crosses the Cherwell just east of the village. The reason can be determined from a plaque mounted on it. This says: 'Site of the Battle of Cropredy Bridge 1644. From the Civil War deliver us.' The bridge was rebuilt in 1780 and the plaque is a facsimile of the original one.

The battle took place on 29 June 1644 and extended over a considerable area, but Cropredy Bridge was an important point and gave its name to the battle. A Royalist army consisting of about 5,000 cavalry and 4,000 foot soldiers faced a Parliamentary army of a similar size. The result was inconclusive, but the Royalists, commanded by King Charles I, had the best of the battle and it was a setback for the Parliamentarians.

Rivers have had many uses. One was to provide a line of defence and another was to supply the power for water mills. There have been water mills on the Cherwell, but none are left. At one time the river water was of help to the Great Western Railway on its line from Oxford to Banbury. Steam trains scooped it up from troughs laid between the tracks in order to supply the engine's boiler. The river supplied the water for this to be done.

At a point before the river can be seen from the train, the Oxford Canal joins with it for a distance of 1 mile. Once again there is a lock with a very short drop and a lozenge-shaped structure.

The River Cherwell seen from the weir, where it crosses the Oxford Canal.

At Oxford the Cherwell is divided into two close streams as it passes under Magdalen Bridge. It then flows past Christ Church Meadow, before the two streams of water join the Thames. There is a tradition of students jumping off Magdalen Bridge into the river on May Morning (the first day of May). This is dangerous, especially when the water is low, and there have been injuries. For this reason the bridge is now closed on the morning in question.

The M40 Motorway

The M40 motorway is 89 miles long and much of its route lies close to the railway line which is the subject of this book. It is never far away and can be seen in various places. The M40 starts with a link to the M25 motorway near Denham, north-west of London, and it finishes by joining the M42 near Solihull, south of Birmingham. The photograph is taken from a point two thirds of the way between Bicester and Banbury. It has crossed the line 3 miles north of Bicester and it will cross the line two more times before the train reaches Banbury.

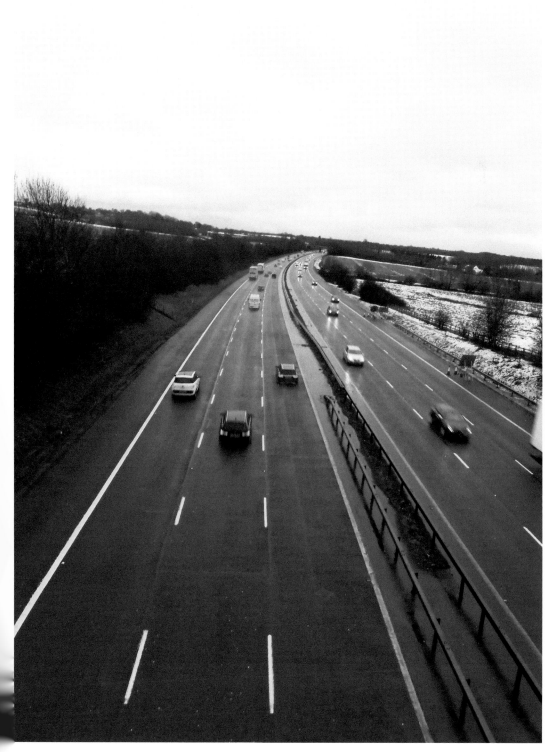

The M40 motorway near King's Sutton.

The motorway was built in two stages, and between them were furious arguments and a long delay. The first stage was from the London end to Wheatley, which is to the east of Oxford. Work started in 1967 and it finished in 1974. It was done as a number of bypasses, which were linked and the road was extended. This accounts for the extensive period for the work.

The main road route between London and Birmingham was at the time along the M1 and M6, but over the years the weight of traffic on these motorways grew and grew. By the late 1980s it was heading towards intolerable levels, so it was decided to implement a long-standing plan and extend the new road from Wheatley to Solihull. This became the M40 motorway, which is the subject of this chapter. As well as relieving pressure on the M1/M6 it would provide much needed relief for traffic in Oxfordshire and elsewhere.

The need was clear, at least to most people, but the precise details of the route were not. In particular it was proposed that the motorway would pass through Otmoor in Oxfordshire, an area of wetland that supported a large amount of wildlife. A public enquiry lasting 117 days recommended that the route not cross Otmoor, but the government disregarded this and decided to stick with its original plan.

This caused an uproar and in response Friends of the Earth and some local people had an inspired idea. They purchased a plot of land lying on the proposed route at Otmoor and named it Alice's Meadow. The name was chosen because of Lewis Carroll's book *Through the Looking Glass* featuring the young girl Alice, who had been the heroine of *Alice's Adventures in Wonderland*. It is believed that the title of the second book was partially inspired by the chessboard-like field pattern of Otmoor.

The field was divided into around 3,500 individual plots, which were individually sold for £2 each. The naturalist David Bellamy was one of the purchasers. Quite a few of the buyers lived abroad, which was designed to make things especially difficult. The purchasers were encouraged to sell the plots on to create a chain of ownership. This, too, was designed to make things difficult for the government.

The effect was that the government would be compelled to go through the compulsory purchase and appeals procedure 3,500 times. To say the least, this was extremely inconvenient, expensive and ridiculous. It was a brilliant idea and it worked. The government changed its mind and the motorway was rerouted around the much-loved area. If you drive on the M40 between Oxford and Bicester, you will have no difficulty in spotting the place where the motorway was rerouted. It is next to the tightest bend in the whole of the country's motorway system. The government surrendered, or perhaps we should be charitable and say that it saw sense in the argument that was put to it.

Work started in October 1987. The section between Warwick and the M42 at Solihull opened in December 1989, and the remainder opened in January 1991. We had the alternative motorway route from London to Birmingham, and according to reports wildlife on Otmoor is thriving. In 1997 RSPB (Royal Society for the Protection of Birds) established a nature reserve on the site. The motorway traffic is flowing, God is in his heaven and the wildlife flourishes. Isn't life grand?

When the motorway was opened there were no services at all, which is one of the reasons that it was much less used than now. Another reason is of course the inexorable rise in the volume of traffic. When it opened it was possible to drive from London to Birmingham (or at least from Denham to Solihull) without the option of using toilet facilities, purchasing fuel or doing the many other things (such as eating, drinking and shopping) that are done at motorway service stations. Lorries were deterred from using

the motorway because the drivers had to take mandatory breaks. Happily the deficiency has been remedied and there are now four service areas. They are at Beaconsfield, Oxford, Cherwell Valley and Warwick.

King's Sutton in Banburyshire

Banburyshire does not exist as a recognised county, but the term is widely used. It refers to the town of Banbury and the area and villages around it. Banbury is in Oxfordshire and so are parts of Banburyshire, but other parts are in Northamptonshire and Warwickshire. Banburyshire contains some beautiful countryside and some lovely villages. The train passes through it on its approach to Banbury from Bicester.

The exceptional village of Aynho is in Banburyshire, 6 miles before Banbury, and I very much hoped to make it a separate chapter in this book. However, no part of it can be seen from the train, so I resisted the temptation. The train passes the disused Aynho Station and Station Road links this with the village, but the village itself is hidden by the brow of a hill. Aynho village is famous for the apricots grown on the walls of the houses, and for the historic country house of Aynho Park.

Happily, the village of King's Sutton is right next to the line and is a worthy representative of the Banburyshire villages. It is on the right side of the train, 2 miles beyond the disused Aynho Station and 4 miles before Banbury. The population (as per the 2011 census) was 2,112 and it has much to commend it, not least the Church of St Peter and St Paul, which appears in this chapter's photograph. The remarkable spire can be seen by looking upwards from the station and just afterwards.

St Peter and St Paul's Church, which is Grade I listed, possibly contains some Saxon material, but the present building was begun in the twelfth century and was completed around the year 1400. The magnificent spire rises to a height of 198 feet and it is believed that it was added to the tower in the late fourteenth century. More than one source quotes Sir Niklaus Pevsner as describing it as 'one of the finest, if not the finest, spire in this county of spires'. I was not familiar with the name but I ascertained that he was a scholar of the history of art, and especially that of architecture. He is most famous for his forty-six-volume series of county-by-county guides *The Buildings of England* (1951–74). So his opinion should be respected. The county in question is Northamptonshire, because King's Sutton is just on that side of the border with Oxfordshire.

King's Sutton and the Church of St Peter and St Paul have connections to Saint Rumbold, though almost everyone will regard the reports as a legend. The story goes that Rumbold was the son of Penda, King of the Mercians, and that he was born in King's Sutton in the year 662 AD. His father was a pagan, but was converted to Christianity by his wife before their marriage was consummated. Incredibly, after his birth Rumbold spoke some holy words, confessed himself to be a Christian and was baptised. He died at the age of only three days. He was buried at King's Sutton, but the body was later transferred to Brackley and then to Buckingham. A shrine was erected for him in the church at Buckingham.

King's Sutton Church offers a variety of services, but most are formal and traditional in style. The Parochial Church Council has requested Alternative Episcopal Oversight. The phrase was not known to me but, subject to conditions, this is available to churches that

The Church of St Peter and St Paul in King's Sutton.

on doctrinal grounds do not feel able to accept the authority of women priests and women bishops. Instead they are put under the authority of a so-called 'flying bishop'. Despite the church's geographical location it comes under the authority of the Bishop of Richborough, who shares these views. They are keen to make clear that they welcome everyone, regardless of their position on the issue.

A village with such an old church must have a long history, and it does. Its name is derived from 'King's South Estate'. There was a Roman settlement close by and coins from the fourth century AD have been recovered from it. King's Sutton was once a location for the extraction of saltpetre (potassium nitrate), which is used in the manufacture of gunpowder. For this reason it had some importance in the English Civil War. A Royalist garrison based in Banbury utilised it for the King's army.

Olga Kevelos, who died in 2009, is a fondly remembered resident of the village. For twenty-six years she helped her brother run the Three Tuns Public House. Born in 1923, she spent the last two years of the war as part of all-woman crews operating narrowboats on the Grand Union Canal. It was hard, demanding and valuable work. She was often hungry and, among other things, pulled the bodies of unwanted babies from the canal and fought off the unwanted advances of a transsexual colleague. Afterwards she took up motorsport and became the country's leading woman motorcyclist. She won gold medals in the 1949 and 1953 International Six-Day Trials and was the only woman to do this twice. For nearly thirty years she was very active in numerous events and competed in every International Six-Day Trial until 1966. She did not retire from the sport until 1970.

In 1978 Olga competed in the BBC quiz programme *Mastermind*, and she selected Genghis Khan as her specialist subject. Many years later she met the Prime Minister, Tony Blair, at a reception, and he was very interested in discussing Genghis Khan with her. She irreverently said afterwards: 'He probably wanted a few tips on how to invade other people's countries successfully.' It is not surprising that she is remembered for her sense of humour.

Shortly before King's Sutton, and up to almost Banbury, four forms of transport run closely together. The railway is one and the three others are on the left side of the train. They are, in order progressing away from the train, the River Cherwell, the Oxford Canal and the M40 motorway. They are the subjects of the three previous chapters. The railway, the canal and the motorway are manmade. The river has been there since time immemorial[*] and at that stage would only accommodate exceedingly small and primitive boats.

Banbury

Banbury is a historic market town, busy and prosperous with a population (as per the 2011 census) of 46,853. It is 15 miles beyond Bicester and 2 miles beyond King's Sutton. What are the two things that instantly come to mind at the mention of the town's name? In my case it is Banbury Cross and Banbury cakes.

[*] The legal definition of time immemorial is a time before legal history and beyond legal memory. By the first Statute of Westminster in 1275 the time of memory was limited to the reign of King Richard I, which began on 6 July 1189. So, time immemorial is the period before this date.

At the time of the Reformation Banbury had three crosses: High Cross (also known as Market Cross), Bread Cross and White Cross. Before the Reformation towns with crosses were places of Christian pilgrimage. During the ensuing period of religious turmoil this made them controversial and the three crosses were destroyed by the Puritans in about the year 1600. Banbury was then without any cross for more than 250 years.

The present Banbury Cross was erected in 1859 and is at the intersection of four roads in the centre of the town. It stands 52 feet 6 inches high to the top of its gilt cross, and is of neo-Gothic design. It was built with niches for three statues and these were added in 1914. The Cross was built to commemorate the marriage of Queen Victoria's eldest child, Victoria Adelaide Mary Louise, to Prince Friedrich Wilhelm Nikolaus Karl of Prussia on 25 January 1859. Vicky, as she was known, was betrothed at the age of sixteen and was only seventeen years and sixty-five days old at the time of her marriage. Although there was genuine affection between the couple, it was to some degree a political marriage.

During the forty-three years until Queen Victoria's death, Vicky sent her mother no fewer than 4,000 letters. Queen Victoria, who sent letters rather like Donald Trump tweets, sent her 3,700. Vicky, who was an extremely intelligent and well-meaning lady, did not have an easy life. She was happily married but was not widely respected and was even disliked.

Vicky and her husband wanted to steer Prussia (later Germany) in the direction of a liberal democracy, rather like the English model. This did not accord with the views of her father-in-law, her mother-in-law and much of her husband's family. It also did not accord with the views of Bismarck (the long-serving German Chancellor) and her eldest son, who became Kaiser Wilhelm II of Germany. They all thought that there was much to be said for autocracy. The Prussians (later Germans) resented her because she was too English, but she was not popular with the English because she had become Prussian. To make matters worse, her husband ruled for just ninety-nine days in 1888 before dying of cancer. Vicky died of cancer as well at the age of sixty, just a few months after the death of her mother, Queen Victoria.

Vicky's eldest son, the future Kaiser Wilhelm II, was born just a few weeks after her eighteenth birthday, and due to a horrendously difficult breech birth he was born with a withered left arm. It handicapped him for his entire life and it damaged him psychologically. Vicky had insisted on being treated exclusively by English doctors and she agreed that Wilhelm should endure some very painful treatments to try and correct the problem. She had also agreed that he must learn to ride, despite the fact that he frequently hurt himself by falling off the horse. This did ultimately work. It was of course all done with the best of intentions. It is an extremely fanciful thought but perhaps all this was a factor in Wilhelm's part in provoking the First World War. Although it was grossly unfair, he blamed his mother for his handicap. Poor Vicky!

As mentioned earlier, three niches were left vacant when the Cross was built in 1859. They were filled in 2014 with statues of Queen Victoria, King Edward VII and King George V. This was done to commemorate the coronation of George V.

Banbury Cross is indelibly linked with the words of a children's nursery rhyme:

Ride a cock horse to Banbury Cross,
To see a fine lady upon a white horse;
With rings on her fingers and bells on her toes,
She shall have music wherever she goes.

Banbury Cross.

The first record of the words being written date to 1784, but the rhyme is considerably older and there are several versions of it. The cross in question was not the one that can be seen now, but one of the earlier crosses destroyed by the Puritans. There is no consensus about the identity of the lady on the horse, though she was presumably rather grand. One possibility is Queen Elizabeth I, who paid a visit to the town. Another is that she was Celia Fiennes, whose father was the brother of the 3rd Viscount Saye and Sele. In this case the phrase would be 'to see a Fiennes lady' rather than 'to see a fine lady'. A charming footnote is that William Gladstone, the Victorian Prime Minister, was known to sing the rhyme to his children while bouncing them on his ankle.

The nursery rhyme has inspired the impressive White Lady Statue, which stands close to Banbury Cross. It was funded and erected by the people of Banbury, and was unveiled by Princess Anne in 2005. It was designed by Artcycle Ltd and was sculpted by Denise Dutton. They did a good job. It depicts what the nursery rhyme says and includes rings and bells. I liked it, but was surprised by one thing: the whole statue, including the horse, is black. I expected to see a white horse.

Banbury cakes are not as famous as the Banbury Cross, but they are well known. They have a long history and the recipes have varied over the centuries, but a Banbury cake is now a spiced, currant-filled, flat pastry cake, with three slashes on the top. The filling typically includes mixed peel, brown sugar, rose water, nutmeg and perhaps rum. It is similar to an Eccles cake but is more oval in shape.

The cakes are still made and sold in Banbury, and they are sold elsewhere in the country and abroad. They stay fresh for four weeks after cooking. A Banbury cake recipe was first published in 1615, but they were being made long before then. In fact, some people believe that the recipe was brought back from the Crusades.

As stated at the beginning of this chapter, Banbury is a historic town with a long history. The names of most old towns have changed over the centuries and this one is not an exception. It is believed to be derived from Banna, a Saxon chieftain said to have built a stockade there in the sixth century. The Saxon spelling was Bannesbyrig. It appears in the Domesday Book of 1086 as Banesberie.

The remains of an Iron Age community have been found in the town. The area was settled by the Saxons in the late fifth century, but the times were turbulent and in about the year 556 it was the site of a battle between the Anglo-Saxons and a group of Romano-British. The Saxons built Banbury on the west side of the River Cherwell and Grimsbury on the east side. They were separate but Grimsbury was formally incorporated into Banbury in 1889. In the early Norman period it was held by the Bishop of Lincoln. The town prospered and in the thirteenth century a lot of its wealth was derived from wool trading.

Banbury was a divided town during the English Civil War. It contained many Puritans and most of the population supported the Parliamentarians. It is claimed that Oliver Cromwell planned the Battle of Edge Hill while in the town. Parliamentary troops were billeted in nearby Hanwell for nine weeks and the villagers petitioned the Warwickshire Committee of Accounts to pay for feeding them. On the other hand, troops loyal to Charles I were garrisoned in Banbury Castle. This had been built in 1135 but was demolished after the war ended with victory for the Parliamentarians.

Banbury has benefited from good transport links, and it still does. The Oxford Canal reached the town from the north in 1778 and this opened up a cheap and reliable source of Warwickshire coal. The canal going south reached Oxford and the River Thames in 1790. The first railway reached it in 1850 and at one time it had two stations. The Great Central Line arrived in 1900 and the town occupies an important point on the rail network.

In more recent years Banbury has benefited greatly from the construction of the M40 motorway, which passes close to it. From 1931 Alcan Industries was a major employer and its plant covered no less than 53 acres, but it has now gone. Douwe Egberts, which produces instant coffee, is very large, and there are other major employers. Banbury has links with motorsport, benefiting from its proximity to Silverstone. The town once had an exceptionally large cattle market, but this closed in 1998.

Banbury is three quarters of the way through our journey from London to Birmingham and it is an attractive town. This must be true because it features in a poem by the former Poet Laureate John Betjeman. The poem in question has the extraordinarily long title 'Great Central Railway, Sheffield Victoria to Banbury'. The last eight lines are as follows:

> *Is Woodford Church or Hinton Church*
> *The one I ought to see?*
> *Or were they both too much restored*
> *In 1883?*
> *I do not know. Towards the west*
> *A trail of glory runs*
> *And we leave the old Great Central Line*
> *For Banbury and buns.*

This is probably the best ending of a chapter in the whole book.

Burton Dassett Hills Country Park

Burton Dassett Hills Country Park covers 100 acres and it amounts to a number of rugged hilltops and a small wood. It is on the left side of the train and the hilltops can be seen in the distance from several points. They are behind the village of Fenny Compton, which cannot be seen from the train.

It is worth a visit, partly because of its geology and history, partly because of its beauty and partly because of its views. It is ideal for walks, picnics and kite flying. The highest point is 666 feet above sea level and the views are stunning. They mostly cover beautiful, open countryside and I have been told that it is sometimes possible to see Coventry, which is 20 miles away. A visit can at times be a bleak experience, as I discovered. When I went it was a freezing January day and the wind seemed to have started gathering speed in the Arctic Circle. This was a few days after I went to the Chesterton Windmill, which is the subject of the next chapter. That was even colder and more exposed. Of course, these experiences are very much the exception.

The area was made a Country Park in 1971 and it is run by Warwickshire County Council. If time permits after a visit, a look at the nearby twelfth-century All Saints Church is worthwhile.

The hills have their geological origin in the Jurassic Period, which as you may know was between about 200 million and 140 million years ago. At that time the area that became Britain was closer to the equator and the climate was similar to what we would now call subtropical. The Burton Dassett area was under a shallow sea. This accounts for the numerous fossils of sea creatures that have been discovered, and which in some cases may still be found. The ironstone in the Burton Dassett Hills was formed at this time and afterwards.

The Beacon at
Burton Dassett Hills
Country Park.

Ironstone was quarried from the area of the park during the latter part of the nineteenth century until shortly after the First World War. At one time a steam-powered overhead ropeway ran between the quarries and a nearby railway goods yard. This transported the iron ore in a system of suspended buckets. As can be imagined, the quarrying exposed the fossils of oysters, scallops and the other creatures from the Jurassic Period.

The hilltops can be very windy, which made it a good place to build a windmill, but this is said with the proviso that too much wind can be a problem. For many years a windmill stood next to the beacon that is described later in this chapter, but unfortunately in 1655 it was destroyed in a storm. This was replaced in 1664 and the new one continued until about 1912, when it ceased working. With the help of public funds it was restored in 1933 and lasted until 1946. It was then wrecked by another storm and was not replaced.

In 1908 a grisly find was made by quarrymen on Pleasant Hill, which is within the Park. It was a Saxon burial site and consisted of two trenches. They contained thirty-five skeletons lying head to foot. Pottery and a Saxon sword were also found. Injuries indicated violent deaths, and it is believed that they died in battle during the sixth or seventh century.

This chapter's photograph shows the Beacon, which is probably the most memorable feature in the Park. It is a sturdy round tower built of uncoursed, rough ashlar. It is set on a raised platform revetted by rough masonry. The roof is conical and covered with cement. The diameter at the base is 6.8 metres and it is 4.8 metres high. The structure is a Grade II listed building.

According to Burton Dassett Parish Council, Sir Edward Belknap was responsible for having it built, though it probably replaced earlier beacons. Again according to the Council, he was rather an unpleasant man who was cruel to his tenants, but it is him we should thank for the Beacon. Sir Edward died in 1520, so it has been standing for at least half a millennium. It seems likely that its purpose was to act as a signalling tower, and that on the top there would have been a cresset in which to light a fire in times of emergency.

Transmitting warnings or messages by signalling from high points has a long and effective history. In 1797 the Royal Navy mutinied at Spithead near Portsmouth and Captain Patton sent a warning message to the Admiralty in London. This was despatched from Southsea Beach and the means of transmission was semaphore. It was relayed from high point to high point and reached the roof of the Admiralty building in just a few minutes.

The Country Park is close to Edgehill, which cannot be seen from the train. Like Burton Dassett this has been a source of ironstone, but it is famous because in 1642 it was the site of the first pitched battle in the English Civil War. Each side fielded about 15,000 men. The result was indecisive and both sides claimed victory, but it is probably correct to say that the Royalists had the best of it.

The address of Burton Dassett Country Park is Southam CV47 2AB. The telephone number is 024 7630 5592.

Chesterton Windmill

The novelist Jane Austen died in 1817, but had I been able to consult her she may well have said that it is a truth universally acknowledged that a book such as this must be in want of a windmill.

Miss Austen would have been right and in writing the book I have been mindful of it. A windmill at Lacey Green would have been included, but it was just over the brow of a hill. The same applies to one at Brill, which is near Thame. However, we have got the best of the three and it is one of the most notable in the country. It is visible from the train for some way.

Chesterton Windmill can be seen for a while about 6 miles beyond Burton Dassett Hills Country Park and 3 miles before Leamington. It is exposed on the top of a hill, on the left side of the track, about half a mile from the train. It is easy to identify because it is standing on six arches.

The windmill was built around 1632–33, and it is believed that Sir Edward Peyto, who was Lord of Chesterton Manor House, was responsible. Claims have been made that Inigo Jones[*] was the architect, but this seems very improbable. It is, however, probable that his

[*] In 1973 Royal Mail introduced a set of four commemorative postage stamps to honour the great architect Inigo Jones. Two of the stamps were priced at 3p and two were priced at 5p. It is interesting and rather sad to compare these values with the price of stamps today. At the time of writing a second-class stamp costs 58p and a first-class stamp costs 67p.

work was influential. At that time one of his pupils, John Stone, was designing the new Chesterton Manor House, and it is likely that he designed or influenced the design of the windmill. Inigo Jones was the first English architect of great significance. The Chesterton Windmill is the earliest tower mill in England to retain any of its working parts and this alone makes it very important.

Since 1633 there have been three major reconstructions of the mill. The first was in 1776 when the mill shaft was modified. At the same time the date was carved in the tail of the shaft. In 1860 the old curb and cap framing was altered. By 1910 the winding gear had ceased to operate properly and milling was stopped. In the early 1950s one of the sails fell off and it was restored some years later. In 1966 a major reconstruction began and this was completed in 1974. The result of this is what can be seen today. Warwickshire County Council was responsible for the last reconstruction and they are now the guardians of the windmill.

The windmill is built of local limestone with sandstone detailing. The shallow platform has a diameter of just over 71 feet and the tower has a height of 36 feet. The six arches are surmounted by a sandstone string course that runs round the tower. Part of a plaque at the mill reads as follows:

The design of the mill is unique both structurally and mechanically.

Originally there was a central timber structure containing a staircase and the lower bay of the hoist.

Most of the gearing is of timber, two outstanding items being the compass arm fixing of the eight feet diameter brake wheel and the lantern pinion wallflower. The millstones are on the first floor set on a timber frame known as a hurst, an arrangement not often found in English windmills. The sails are of the common cloth spread type. The cap is turned into the wind by a hand operated geared winch mounted on the framework in the cap, which engages with a rack located on the top of the tower.

My visit to the windmill was on a bitterly cold January day and the ground underfoot was very muddy. The nearest place to park the car was 300 yards away and it was necessary to squelch across a field. I was the only person in sight. It was nevertheless a very enjoyable experience, which means that it would have been even better in good weather. I can recommend a visit.

During my solitary contemplation I was puzzled to see that two bunches of flowers had been laid at the foot of one of the arches. They were almost new and wrapped in cellophane, but there were no cards or other indications of their purpose. They reminded me of the sad tributes sometimes laid at the scene of a fatal road accident. I have no idea why they were there. Perhaps someone had recently died at the spot or perhaps it was an anniversary of this happening. On the other hand, perhaps it was a tribute to someone who had loved spending time there. This could correspond to donated seats at beauty spots to mark the life of a loved one. I will never know but it was a poignant experience.

The address of Chesterton Windmill is Windmill Lane, Leamington Spa CV33 9LB. It is open to the public during some heritage weekends in spring and autumn. Details may be obtained from heritage.warwickshire.gov.uk.

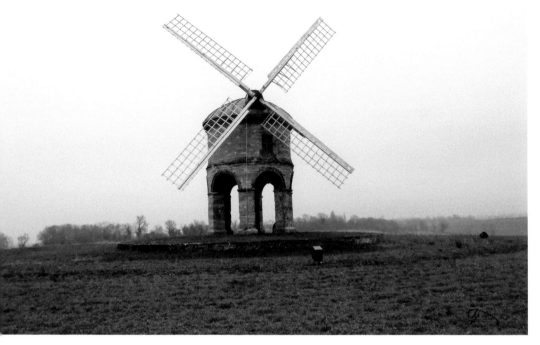

Chesterton Windmill.

Fosse Way

And did those feet in ancient time
Walk upon England's mountains green
And was the holy Lamb of God
On England's pleasant pastures seen?

This is the opening verse of the hymn *Jerusalem*, which George V reportedly said would be a better national anthem than *God Save the King*. The stirring words are from a poem published by William Blake in 1808, and the tune was composed by Sir Hubert Parry in 1917. It was adopted by the suffragettes and Parry gave the copyright to the National Union of Women's Suffrage Societies (NUWSS). When this organisation was disbanded in 1928, the copyright reverted to Parry and his executors assigned it to the Women's Institutes. It is sung at their meetings to this day.

If those feet did walk on the mountains green, they must have walked on roads or tracks to get there, and they may well have used the road shown in this chapter's photograph. The train passes over it on a bridge just after the view of Chesterton Windmill and shortly

before the outskirts of Leamington Spa. The road is the Fosse Way, which a long time ago was built by the Romans. It is now tarmacked, but it is the original road and you will be looking at the place that Romans trod.

The Fosse Way linked Exeter (Isca Dumnoniorum) in south-west England with Lincoln (Lindum Colonia) in the East Midlands. The word 'fosse' is derived from the Latin *fossa*, meaning ditch. It was constructed in the first few decades after the Roman invasion of Britain in AD 43 and is one of the earliest Roman roads in Britain. It was built to mark what was then the western frontier of Roman rule in Britain. It is possible that it was built as a defensive ditch that was later filled in and converted to a road, but it could be that a defensive ditch ran alongside the road for at least some of its length.

As all schoolchildren should know but perhaps do not, the Romans were famous for building straight roads, going over obstacles, not around them. Fosse Way is the supreme

The Fosse Way.

example of this: Ilchester in Somerset to Lincoln is 182 miles and it comprises most of its length. At no point does Fosse Way deviate by more than 6 miles from a straight line. With the skills to achieve that, no wonder the Romans were so successful.

Several place names on the route incorporate the suffix *cester* or *chester*, which is from the Latin *castra*, meaning military camp. The previously mentioned Ilchester is an example. Other place names are based on the Latin *strata*, meaning street. Examples are Street Ashton, Stretton-under-Fosse and Stratton. At the time that Fosse Way was built, rivers were not channelled and not as deep as they often are now. For this reason Fosse Way was able to ford the River Soar at Leicester and to ford other rivers too. The Roman Watling Street was able to cross the Thames at London for the same reason.

The story of Fosse Way started with the first verse of Blake's *Jerusalem*, and it is appropriate to end with the last:

I will not cease from mental fight
Nor shall my sword sleep in my hand
Till we have built Jerusalem
In England's green and pleasant land.

The words continue to inspire. We have work to do.

Leamington Spa

The town of Leamington Spa is reached shortly after the Chesterton Windmill and Fosse Way, and it is approximately three quarters of the way from London to Birmingham. Much of it is very attractive, though the area around the station is by no means the best part. The 2011 census put the population at 49,491 and it is bisected by the River Leam.

A town with the word Spa in its name is bound to contain springs delivering water with medicinal value, and of course this is true of Leamington Spa. They were the reason that the small village of Leamington Priors expanded into the fashionable resort of Leamington Spa. The first mineral spring was recorded in 1480 and five others were found in the late 1700s. There was a further discovery in 1804 and the springs were commercially developed. Facilities included marble baths with dressing rooms, cold baths, children's baths, well houses, Turkish baths, hot air baths and a douche bath. Some people believed that the spring water was an effective treatment for rabies.

James Bisset was a Scottish businessman who moved to Leamington in 1811, and in 1814 he wrote a guide book to publicise its attractions. This contained his poem which he entitled 'Rules for Drinking the Waters'. It read as follows:

At early dawn prepare to rise,
And if your health you really prize,
To drink the waters quick repair,
then take a walk to breathe fresh air,
Hie thro fields – or promenade
Round pump rooms grand, or colonnade.

A second glass now take – what then?
Why! Take a pleasant walk again,
The Waters, exercise and air,
Will brace your nerves, your health repair.

Then to your breakfast haste away,
With what keen appetite you may.

Queen Victoria visited Leamington as a girl and in 1838, when she was the nineteen-year-old monarch, she gave permission for the town to incorporate the word 'Royal' into its name. So it is Royal Leamington Spa. This is sometimes included and sometimes not.

Victoria's statue is prominent in the town and during the Second World War the blast from a German bomb was powerful enough to shift it by a distance of an inch. It is hard to think of a reason why the Luftwaffe would target Leamington. Surely they did not think that inconveniencing people taking the waters would cripple the war effort. It must have been a mistake, or possibly they were targeting the Ford Foundry.

The colonnaded Royal Pump Rooms were opened in 1814 and feature in the photograph accompanying this chapter. They are Grade II listed and the most famous of the Spa buildings. The Rooms were redeveloped in the late 1990s and are now home to the art gallery and museum, the library, the assembly rooms, the visitor centre and a café. Outside, near the bridge over the River Leam, is a fountain providing the only publicly available spa water in the town.

The centre of the town includes attractive buildings from the Georgian and early Victorian periods, with the seven-year reign of William IV in between. They include the Parade and the Grade II listed Lansdowne Crescent. I speak from experience that they are pleasing to the eye. A plaque in the town marks the spot held by some to be the centre of England. This is a matter of dispute because there are different ways of making the calculation and there are other claims. In particular Meriden in Warwickshire and Fenny Drayton in Leicestershire have their advocates.

The most notable park is Jephson Gardens, which is in the centre of the town. This features a lake with fountains, and the Czech War Memorial commemorates members of the Czech Free Army who were stationed in the town in the Second World War. Seven of them parachuted into Czechoslovakia to take part in the attempt to assassinate the Nazi general Reinhard Heydrich.

A long time ago I spent a few happy months working as a financial analyst at Ford's Imperial Foundry in Leamington. It made parts for Ford vehicles, but sadly it was closed in 2007 with the loss of 365 jobs. This was because the production could be sourced more cheaply elsewhere. It went to the Czech Republic, Serbia, Turkey and other places.

There must be something about this railway line that relates to the poetry of the late, great Poet Laureate Sir John Betjeman. He gets an honourable mention in the first chapter on Marylebone Station, and one of his poems is quoted in the chapter on Banbury. It must be because I like him and his poetry. Leamington features in his poem 'Death in Leamington'. The eight verses are engaging but rather sad. The first verse reads:

She died in the upstairs bedroom
By the light of the evening star;
That shone through the plate glass window
From over Leamington Spa.

The body is found by the nurse and the last verse reads:

> She moved the table of bottles
> Away from the bed to the wall;
> And tiptoeing gently over the stairs
> Turned down the gas in the hall.

Prince Louis Napoleon lived at 6 Clarendon Square in Leamington during the winter of 1838/39, something that is commemorated by a blue plaque on the wall of the house. Prince Louis was the nephew of Napoleon Bonaparte, the Emperor of the French whose reign was ended by defeat at the Battle of Waterloo in 1815. Prince Louis manoeuvred to be ruler of France for many years, and in 1848 he was elected President. In 1852 he crowned himself Emperor Napoleon III, and he reigned until 1870 when France's defeat in the Franco-Prussian War resulted in him being deposed. It is probably true to say that Prince Louis Napoleon was Leamington's most notable resident, but he only lived there for a few months and it was a long time ago.

The boxer Randolph Turpin was born there and died there and his achievements were more recent. Unfortunately, his story has a very unhappy ending. He was mixed race, but for some reason is generally referred to as black. The same applies to Barack Obama, the former President of the United States. Randolph was only the second non-white boxer to win a British Championship. The first was his older brother Dick.

In 1951 Randolph Turpin outpointed the legendary Sugar Ray Robinson to become the undisputed middleweight champion of the world. Robinson won the championship back soon afterwards, and Turpin's later attempt to win the title failed. He had a great career, which included winning the British light-heavyweight title.

Like many great boxers, Turpin fought for too long. At the end he had severe financial difficulties, many of them tax-related, and eventually was declared bankrupt. At the age of thirty-seven and severely depressed he shot his seventeen-month-old daughter and then turned the gun on himself. She survived but he did not. It happened in the loft of their home above a café in Leamington.

World champion boxers usually come from deprived areas, not genteel spa towns. It might be expected that a place such as Royal Leamington Spa would be more likely to have links to sports such as lawn tennis, and in fact it does. The world's first lawn tennis club was established in Leamington in 1872, three years before the game was played at Wimbledon. The founders were Major Harry Gem and three of his friends. In 1875 Major Gem published the laws of the game as it was played in Leamington and the club's first tournament was played in 1876.

Several Wimbledon champions won at Leamington and several Leamington champions won at Wimbledon. William Renshaw of Leamington won seven times at Wimbledon between 1881 and 1889, and his twin brother James won once. Playing together they won the doubles four times. The original Leamington club has had a number of amalgamations. It is flourishing today.

In 2017 a property website called Rightmove pronounced that Leamington Spa was the happiest place in Britain in which to live. How could they possibly know? The answer is that they could not. Still, it was good publicity for Rightmove. I would mark Leamington highly, but based on a survey of one person (me) I can declare that the happiest place in which to live is my home town of Leighton Buzzard.

The Royal Pump Rooms.

Historic Warwick

Warwick is reached almost immediately after leaving Leamington Spa and the town is a gem. It is not called 'Historic Warwick' for nothing. The photograph is of the Collegiate Church of St Mary, which is located on a hill in the centre of the town. The tower and the town are on the left side of the train. The tower is tall and easy to see, and its outline can be seen from as far away as Hatton Locks, which feature in the next chapter. The Visitor Information Centre immodestly but justifiably describes the town in the following terms:

> Warwick is enriched with independent businesses and offers an enticing blend of the old
> and the new, from gift shops, art galleries and fine restaurants. Market Place is the heart of
> the town, hosting a variety of cafés, pubs and shops and a thriving market every Saturday.
> Swan Street is always a hive of activity and the town's busiest shopping street. Smith Street
> is the oldest shopping street in Warwick and boasts a unique mix of independent shops
> and restaurants.

Just how much history does the town have? It was a Saxon settlement in the ninth century AD and the Romans were there too. Warwick School for Boys claims to be the oldest boys' school in England. It is believed that Edward the Confessor chartered it before the

Norman Conquest. It was certainly re-founded by Henry VIII in 1545. Warwick Castle was established in 1068 and the Earldom of Warwick was created in 1088. The earls controlled the town in the middle ages and they built the town walls, of which Eastgate and Westgate survive. During the English Civil War the town was garrisoned for Parliament and it withstood a two-week siege by the Royalists.

Much of the medieval town was destroyed in the Great Fire of Warwick in 1694, although a number of older timber-framed buildings survive. As a result most of the buildings in the town centre are of late seventeenth and early eighteenth-century origin. Within a few months of the fire an Act of Parliament regulated the rebuilding of the town, specifying such things as the width of the streets and the height of the buildings. The work was completed swiftly and it was done when the fashionable style of building was particularly beautiful and elegant. It is typical of the reigns of Queen Anne and George I.

The Collegiate Church of St Mary was founded in 1123 by Roger de Newburgh, the 2nd Earl of Warwick. The crypt still remains from this original building and contains a rare example of a medieval ducking stool. The Chancel, Vestry and Chapter House were rebuilt in the fourteenth century by Thomas Beauchamp, and his tomb stands in front of the high altar. The tiny figures around the base of the tomb are particularly noteworthy. It also houses the tombs of Robert Dudley, Earl of Leicester, his brother Ambrose Dudley, Earl of Warwick, and Robert's son, who died as a young child. He was affectionately known as the 'Noble Impe'.

The Nave and the Tower were destroyed in the great fire of 1694 and were rebuilt by 1704. The tower, which is 130 feet tall, is so prominent because it is on a hill and because it is not obscured by surrounding buildings. There is only room for this brief description of the church and the tower but much more could be said and can be seen by visitors. As well as being beautiful, it tells us about our country's long history and is worth a visit.

For many people Warwick Castle will be the principal reason for visiting the town and an account of this follows, but before this other things should be mentioned. First is the stuffed bear at the Market Hall Museum. This is a real bear, possibly shot in the Aleutian Islands. It was donated by the Dugdale family of Wroxhall Abbey in 1912. While at the Abbey it stood in the hall with a silver salver on its outspread paw waiting for visitors' calling cards. The bear and ragged staff is the insignia of the Earl of Warwick, of the local government and of many local businesses. Few would now condone the shooting of bears, but the animal perished a long time ago. Another must see is the Lord Leycester Hospital. This is not a modern hospital, but a group of medieval buildings of great historic interest. They were acquired by the Earl of Leycester in 1571 as a home for old soldiers.

Warwick Castle, which is situated on a bend in the River Avon, was family owned until 1978. It was then acquired by the Tussauds Group, which became Merlin Entertainments Group in 2007. It is now a major visitor centre and modern-style tourist attraction with, many would say, prices to match. However, there is much to see and study, a wealth of history to soak up and a great deal of fun, so you get a lot for the money.

The story starts in AD 914 when Ethelfreda, the daughter of Alfred the Great, ordered the building of an earthen rampart. Then, in 1068, William the Conqueror commanded the building of a motte and bailey fort. Twenty years later he created Henry de Beaumont as Constable and 1st Earl of Warwick. In 1260 the castle's wooden construction was replaced by stone.

That was more than three quarters of a millennium ago and the castle and its various owners and occupiers have played major parts in the history of our country. There have been four creations of the title Earl of Warwick and there has been a short-lived Duke of

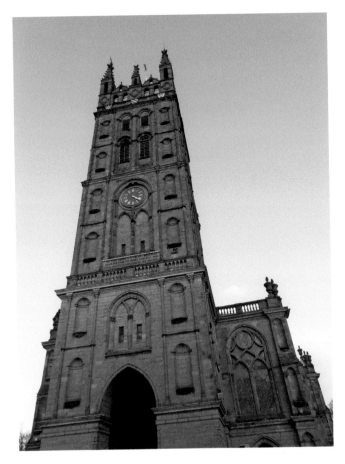

Collegiate Church of St Mary.

Warwick. More than one Earl of Warwick has been executed for treason and one owner of the castle was murdered. In 1431 the then Earl of Warwick supervised the trial of Joan of Arc and her subsequent burning at the stake. During the English Civil War the castle withstood a siege and Royalist soldiers were imprisoned in it.

Among other things visitors can enjoy the battlements, towers, great hall, armoury, the Horrible Histories Maze and the grounds and park. Special mention should be made of the Warwick Trebuchet, which is 59 feet tall, weighs 22 tonnes and is one of the world's largest siege engines. It is located on the river bank below the castle and is able to hurl a rock weighing 330 pounds a distance of 980 feet and at a maximum height of 82 feet. It has hurled a projectile weighing 29 pounds a distance of 817 feet at a speed of 121 miles per hour.

The Grand Union Canal and Hatton Locks

The Grand Union Canal is the M1 of the canal world. It is 137 miles long, and at the south-eastern end a lock links it with the River Thames at Brentford on the edge of London. The north-western end is at Salford Junction in Birmingham. It starts running close to

the railway line shortly before Leamington Spa, then passes through Warwick and on to Solihull. The canal can be seen on the right side of the train in several places shortly after Warwick. The train is very close to the Hatton Locks and the first lock of the flight is close to Warwick Parkway Station. A small part of the flight can be seen from the train.

The canal started life as the Grand Junction Canal. Passage from London to Birmingham was already possible via the River Thames and the Oxford Canal, but the new route took 60 miles off the journey and avoided periodic navigation problems in the Upper Thames. The years 1793/94 were the high point of canal mania – in these two years there were thirty-eight Acts of Parliament for canal building, and in 1793 work was in progress for sixty-two different canals. They became the waterways that fed the Industrial Revolution. The Parliamentary Bill for the Grand Junction Canal was passed in 1793 and the work was completed in 1805. All the work was done by navvies using shovels and barrows. There were no mechanical aids.

The Grand Junction was a great commercial success, but only for a short time. The coming of the railways provided almost insurmountable opposition. The Grand Junction responded by lowering its tariffs, but this hit profits badly and left it short of funds for investment and maintenance. In the twentieth century motor vehicles did the same thing to the railways and what was left of the canal traffic.

In 1929 the Regent's Canal Company bought the Grand Junction and also the three Warwick canals. They became part of the new Grand Union Canal, which ran from London to Birmingham, and the name Grand Junction disappeared. The Grand Union Canal was

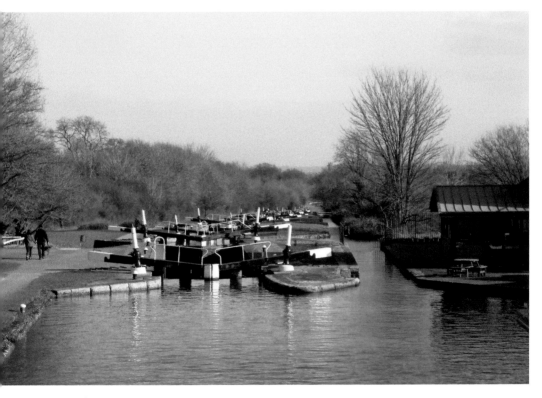

Hatton Locks.

nationalised in 1948 and control was given to the British Transport Commission. In 1962 responsibility passed to the British Waterways Board (later British Waterways).

By the early 1960s the canals were in a bad way. Freight traffic had almost finished and the increase in leisure traffic was in its infancy. They badly needed a lot of maintenance and investment. Happily, the use of the canals for leisure purposes has since blossomed and they are now recognised as a valuable leisure resource. Towpaths have been restored and are widely used for walking and cycling. Fishing remains very popular.

Hatton Locks is a flight of twenty-one locks within a distance of less than 2 miles, and they rise a total of 148 feet. They have somewhat fancifully attracted the sobriquet 'stairway to heaven'. My visit was on yet another cold and windy day, though not as cold and windy as my experiences at Burton Dassett Hills Country Park and Chesterton Windmill. I could, however, appreciate how they acquired the very favourable name. This time I had my daughter-in-law and two of my granddaughters to keep me company. After taking the photograph and soaking up the beauty, we rapidly repaired to the excellent nearby Hatton Locks Café.

The original flight of locks was opened in 1799 by the Warwick & Birmingham Canal, and they could originally only accommodate boats with a width of 7 feet. In the early 1930s they were replaced with ones having double the width. These could take two 7-foot-wide boats or one boat 14 feet wide. In several places the remains of the original locks can be seen at the side of those that replaced them. The new flight of locks was declared open by the Duke of Kent in 1934. There was a grand opening ceremony featuring bands and large crowds.

Hatton village is nearby and it has an unmanned railway station on the line.

The Forest of Arden, Lapworth and Dorridge

The photograph is of the Church of St Mary the Virgin, located just outside the village of Lapworth. It is a fine church serving a fine village and there is more about it later in this chapter, but for now it is sufficient to say that it is located within the area of what was once the Forest of Arden. So are many other places, including the cities of Birmingham and Coventry.

Until the Middle Ages much of England was covered in trees. The Forest of Arden was an enormous area, stretching from Stratford-on-Avon (in Warwickshire) in the south to Tamworth (in Staffordshire) in the north. It was approximately bounded by the Roman roads of the Fosse Way, Icknield Street, Watling Street and a prehistoric salt track leading from Droitwich. So the train enters the area of the Forest just before Leamington Spa and stays within it all the way to the centre of Birmingham. There is no forest to see now, but there are still many woods.

A number of villages have the word 'Arden' in their names. They include Henley-in-Arden, Tamworth-in-Arden and Hampton-in-Arden. The last of these has a station on the London Euston to Birmingham New Street line and has a chapter in my book *Great Railway Journeys: London to Birmingham by Rail*. An ancient stone known as ' Coughton Cross' marks the south-western corner of the forest at the junction of Icknield Street and the salt

Church of
St Mary the
Virgin near
Lapworth.

track. It is now owned by the National Trust and according to local tradition travellers prayed there for safe passage before entering the forest.

Britain's greatest playwright, William Shakespeare, has strong connections with the Forest of Arden. He grew up and went to school in Stratford-upon-Avon, which is on the edge of the forest. His mother's maiden name was 'Arden', which says a lot. She was the daughter of Robert Arden and the family had been prominent in the area since before the Norman Conquest. Research by an organisation called IllicitEncounters.com claims to reveal that the inhabitants of Stratford-upon-Avon engage in more adultery than anywhere else in England. The least adultery is in Wigan. This is probably not true, but in any case it is much ado about nothing.

Who wrote Shakespeare's plays? Most people think that Shakespeare did and I am one of their number. However, there are doubters and Christopher Marlowe and the Earl of Oxford are two of their favoured candidates. The case for the Earl of Oxford was espoused in a book by a Gateshead schoolteacher with the unlikely name of J. Thomas Looney. Part

of the doubters' case is that Shakespeare lived more than 400 years ago, was not very well educated and probably never travelled further than London. How could he have acquired a comprehensive knowledge of the Royal Court, Scotland, Italy and numerous historical personalities and events?

The play *As You Like It* is a counter to all this. Shakespeare (if indeed it was he) set the play in his own backyard in the Forest of Arden. However, some people dispute this and say that the inspiration was the Ardennes, a heavily wooded area covering parts of Belgium, France and Luxembourg.

Lapworth is a charming and prosperous village with a population of around 2,000, 10 miles north-west of Warwick and 6 miles south of Solihull. Lapworth Station, which is on the Chiltern Line, is used mainly by commuters and reminded me of Denham Golf Club Station, which is featured earlier in this book. It has just fourteen car park spaces, which during my mid-week, midday visit were, surprisingly, not all taken. There was little evidence of cars parked nearby, which seems to indicate that it is not greatly used.

Catesby Lane in Lapworth is named after William Catesby, who lived in the village. He was the father of Robert Catesby, who was the leader of the group of Catholics that formulated the 1605 Gunpowder Plot to blow up Parliament. The failure of Guido Fawkes (Guy Fawkes) to achieve this is celebrated with bonfires and fireworks each 5 November. Robert Catesby was killed while resisting arrest. His head was subsequently cut off and displayed on the roof of the House of Commons.

There are two National Trust properties in Lapworth: Packwood House and Baddesley Clinton. This is unusual for a small village. Packwood House is an imposing timber-framed manor house. It has been extended but dates from Tudor times, and it contains some fine tapestries and an extensive collection of sixteenth and seventeenth-century furniture. Its story, features and contents, to say nothing of the customary café, make it worth a visit.

It is not just the house though. The gardens alone make it worth making the trip. They are extensive, beautiful and include a lake. The most famous part is the Yew Garden. This is said to have been inspired by The Sermon on the Mount. Twelve great yews are known as 'The Apostles', four big ones are known as 'The Evangelists', a single yew at the summit of the mount is known as 'The Master' and the others are known as 'The Multitude'. During my visit they were immaculately trimmed and in good condition.

The other National Trust property is Baddesley Manor. This is a moated manor house which is believed to date from the thirteenth century. Like Packwood House it is well worth a visit. The house and its contents are fascinating and there are special events to be considered. At the time of writing they include an Easter egg hunt, outdoor cinema and a number of book fairs.

The house was home to the Ferrers family for 500 years and has a fascinating history. It passed from father to son twelve times and only left the family's ownership in 1940. The owners were committed and active Catholics, which at times was a risky thing to be. As well as the other repression, the 1559 Act of Uniformity made it a treasonable offence to harbour a Catholic priest. This was sometimes done at Baddesley Manor and on occasions several at a time. The house incorporates priest holes and escape routes. They were used and no Catholic priest was ever caught. Catholics reading this need not be concerned. Your visit, if you make one, will be quite safe.

The first stone church at the site of Lapworth's Church of St Mary the Virgin dates to the first part of the twelfth century, though there may have been a wooden one in the Saxon period. Records show that a rector was there in 1190. Subsequent to this the building was developed many times and in many ways. A very unusual feature is the tower. This was built

separately from the church and the spire was added later. It was not until 400 years after the tower was built that a connecting passage to the body of the church was constructed. Another feature of note is the early sixteenth-century clock on the tower. They do not come much older than that.

Dorridge Station is just a few miles beyond Lapworth Station and not far before Solihull. It is bigger and busier than Lapworth Station and is fully staffed, which is to be expected because it is a bigger and busier village. The population is around 8,000. Given its location and the affluence of part of the village and area it is not surprising that it is much used by commuters. I enjoyed my brief visit and was impressed by the place and its atmosphere.

I describe Dorridge as a village because it was the term used by the people to whom I spoke, but how much bigger must it get before it becomes a town? Most villages (and indeed towns) are getting bigger. This chapter closes with three questions guaranteed to start an argument. Try it and see.

- Which way is east?
- What makes a place a city?
- What is the difference between a village and a town?

Solihull

Solihull is 9 miles south-east of the centre of Birmingham, and is just beyond the edge of that city, so when the train reaches Solihull the journey is nearly over. It was formerly in Warwickshire, but is now part of the West Midlands Conurbation. The town of Solihull is the administrative centre of the Metropolitan Borough of Solihull, which includes Shirley, Knowle, Dorridge, Balsall Common, Castle Bromwich, Chelmsley Wood and Meriden. The National Exhibition Centre is within the Metropolitan Borough, and so is most of the area covered by Birmingham International Airport.

Mention of Meriden, which is within the Metropolitan Borough, may well induce thoughts of motorcycles. They feature later in the chapter. It might also induce thoughts about the centre of England. The location of this is disputed, partly because there are different ways of calculating it. As mentioned in a previous chapter, Leamington is one of the claimants, and it has a plaque to say so. However, Meriden has a strong claim too. For 500 years a Grade II listed sandstone monument in the form of a cross has marked what many think is the exact spot.

The believed origins of the names of many towns are difficult to understand and often rather tedious. This is not true of Solihull. It has a very old church called St Alphege's, which was built on a hill of stiff red soil. This often turned to sticky mud in winter. The church was therefore built on what could be termed a soily hill. It is believed that soily hill became Solihull over time. The photograph accompanying this chapter is of the Grade I listed St Alphege's Church. The top part of its spire can be seen from the train when it is in the vicinity of the station. The church has stood in the centre of the town for more than 800 years and it is a highly regarded building.

St Alphege was born in 953 AD. He was the Anglo-Saxon Bishop of Winchester and then the Archbishop of Canterbury. By all accounts, which are admittedly very old indeed, he was a holy and much respected man. Alphege was captured by the Vikings in 1012, and following his refusal to be ransomed he was murdered by them. St Alphege was the first

of four Archbishops of Canterbury to be murdered, the second and most famous being Thomas à Becket in 1120. I do hope that the present incumbent, the nice Mr Justin Welby, will be alright. On the subject of assassination it is surprisingly little known, but one British Prime Minister was assassinated. This was Spencer Percival in 1812.

St Alphege's Church is constructed of red sandstone and dates back to about 1220. The original imposing spire collapsed in 1757 and was replaced by the shorter but still imposing one that can be seen today. This is octagonal and mounted on an embattled tower. It contains a peal of thirteen bells. The church is large and there are no fewer than five chapels in use. One of them is dedicated to St Thomas à Becket, who, like St Alphege, was murdered.

The church is of cruciform plan, and is the only medieval cruciform church in the Diocese of Birmingham. There have been sixteen organists since 1773, and remarkably Dr Courtney Woods held the position for fifty years from 1886 to 1936. He must have been a dedicated man who started at a young age. Just one of the organists was a woman. Jane Fletcher

St Alphege's
Church in Solihull.

held the position for twenty-seven years starting in 1820. It should be mentioned that the long tenure by Dr Woods is by no means a record. For example, in 1922 a new organ was installed at the Salvation Army Hall in Leighton Buzzard and was dedicated to the seven Leighton Buzzard Salvation Army members who died fighting for king and country in the First World War. Sixteen-year-old Herbert Tyler played it during the inauguration service and he was still doing so seventy-five years later in 1997.

Part of Solihull is noted for its timber-framed, Tudor-style houses and shops. It would have been a bigger part but some were demolished in the 1960s to accommodate the building of the central shopping area known as Mell Square. Touchwood, a further large shopping area, was opened by the Queen in 2002. The pedestrianised High Street leads up to St Alphege's Church. It has many individual-type shops and retains a certain charm. At the beginning of the twentieth century Solihull was little more than a large village, but it has since grown very considerably and the population is now more than 200,000.

Many places have trees planted to mark visits or for other special reasons, and this is true of Solihull. A sapling from a tree that Anne Frank could see from her hiding place in Amsterdam was planted at Solihull School as part of the Remembrance Day commemorations in 2015. The planting was done by eighty-six-year-old Auschwitz survivor Mindu Hornick, who was the same age that Anne would have been had she survived. Anne hid from the Nazis and kept a famous diary from 1942 to 1944. She was captured and sent to Auschwitz, and then to Bergen-Belsen concentration camp. She died there, probably of typhus.

Solihull School is a Church of England independent day school, founded in 1560 for boys. It now has over 1,000 pupils aged from seven to eighteen, and relatively recently it became co-educational.

Solihull has and has had close links with motor vehicles of both the two-wheeled and four-wheeled variety. Each type merits inclusion, but we will start with motorcycles. Meriden, which is in the Metropolitan Borough of Solihull, is famous for Triumph Meriden motorcycles and for the ultimately doomed Meriden Workers Co-operative.

Triumph started making motorcycles in Coventry in 1902, and it became a very successful part of the dominant British motorcycle industry. In 1941 its factory in Coventry was destroyed in the Coventry Blitz. Tooling and machinery were recovered from the ruins and production was moved to Meriden. Prosperity continued after the war with a lot of the motorcycles being exported, which was very good for the British economy. However, in time most British motorcycles became uncompetitive and lost out at home and abroad due to competitors in Japan and elsewhere. This happened to Triumph.

In 1972 the BSA Group, which owned Triumph, became insolvent, and BSA/Triumph was acquired by Norton Villiers. As part of its restructuring plan the new owners decided to close Meriden with the loss of 3,000 jobs. The workers were not willing to accept this and for two years staged a sit in.

In 1975 with support from the Labour government and in particular the support of the Minister for Trade and Industry, Tony Benn, the Meriden Workers Co-operative was formed to continue the business. It produced for just one customer, NVT. In 1977 its customer collapsed and the Co-operative bought the marketing rights and continued. This was done with the help of a very controversial loan from the Labour Government. A new company, Triumph Motorcycles (Meriden), was formed. This had some success, but it became uncompetitive and failed in 1983. The then Conservative Government had to write off the outstanding loans given to it by its Labour predecessor.

With its Triumph and Meriden heritage it is appropriate that the Metropolitan Borough of Solihull houses the National Motorcycle Museum. I am not and never have been a motorcycle rider or enthusiast, but I greatly enjoyed my visit. It exceeded my expectations and the admission charge was moderate. The address and contact details are:

The National Motorcycle Museum
Coventry Road
Bickenhill
Solihull
West Midlands
B92 0EJ

Tel: 01675.443311
Email: shop@themm.co.uk
Web: www.themm.co.uk

The museum opened in 1984 with 350 motorcycles, but it now has more than 1,000. They are all British and the oldest one dates from 1898. It now has the largest collection of British motorcycles in the world. As well as the motorcycles, I found the photographs, memorabilia, books and shop fascinating. If you like pictures of the Isle of Man TT races, Geoff Duke, John Surtees and other great racers then this is the place to see them. I could not help but notice that during the TT races the spectators can and do watch from very dangerous positions. Just looking at the photographs frightened me. I also could not help reflecting on the number of casualties. Since 1911, more than 250 riders have died on the TT circuit. This figure does not include marshals or spectators, and it does not include non-fatal injuries.

The production of vehicles of the four-wheeled variety came to Solihull after the Second World War. The reason was the same as the reason that Triumph motorcycles came to Meriden; namely, the bombing of Coventry by the Luftwaffe. Rover had started making bicycles in Coventry in 1878 and its first motor car was made in the city in 1904. Rover was noted for making luxurious, upmarket cars and for many years it did well in its new home.

Land Rovers were rugged, four-wheel-drive vehicles. They were launched from Solihull by the Rover Company Ltd in 1948 and they were its biggest sellers in the 1950s, 1960s and 1970s. The brand has developed to encompass the Defender, Discovery, Freelander, Range Rover, Range Rover Sport, Velar and Range Rover Evoque. They have all been a great British success and still are. Assembly is still in Solihull, but also takes place in India, China and elsewhere.

Towards the end of the twentieth century the British-owned motor industry had a terrible time, and most of it (other than the American-owned Ford and Vauxhall) finished up in British Leyland. This included Rover and Land Rover. Ownership of the brands successively changed and the prestigious name 'Rover' was given to cars made by other marques away from Solihull. It is no longer used.

Despite all the trials and tribulations Land Rover continued to be successful and continued to be made at Solihull. A separate Land Rover company was set up and this was progressively under the ownership of British Leyland, then part of Rover PLC under the ownership of British Aerospace, BMW, Ford and now Tata Motors. This is part of the Tata

Group, which is Indian-owned. Tata also acquired Jaguar Cars Ltd, and Land Rover is part of Jaguar Land Rover Ltd. Range Rover, Discovery Sport, Velar and the F-Pace Jaguar are now made at Lode Lane in Solihull.

Land Rover offers a range of tours at Solihull, and a number of activities and off-road driving experiences at Solihull and other locations. Details are available at www.landroverexperience.co.uk.

Solihull is a big town, so it is not surprising that a number of famous people with close connections to it could be mentioned. However, there is only room for one and the distinction falls to Mandy Rice-Davies, who went to school in the town. Mandy left home shortly after her sixteenth birthday and obtained a job as a showgirl at Murray's Cabaret Club in London. Shortly afterwards she played a part in the so-called Profumo Affair. She is especially remembered for her reply to a question during the trial of Stephen Ward. It was put to her that Lord Astor denied her account concerning himself and his house parties at Cliveden. She replied: 'He would, wouldn't he?' Mandy made a success of the rest of her life. Much later she said: 'My life has been one long slide into respectability.'

I have spoken to two people who knew Mandy Rice-Davies. One was in her class at school and he told me that she had a certain reputation and was a popular girl. I will leave it at that. The other was an auditor who much later was involved with one of her companies. He said that she was very astute and very charming.

In 2013 the uSwitch Quality of Life Index rated Solihull as the best place to live in the United Kingdom. A number of factors in 138 towns and regions were recorded and compared. The things measured included income, life expectancy, household bills, income and broadband speeds. Solihull's figures included life expectancy of eighty-one for men and eighty-four for women, cheaper than average car insurance premiums and broadband speeds of 17 Mb.

St Andrew's Stadium:
Home of Birmingham City Football Club

St Andrew's Stadium is on the right side of the train, about a quarter of a mile from the line. It is about a mile before the end of the journey in Birmingham.

The stadium is in the Bordesley district of Birmingham and has been the home of the football club since 1906. The early capacity was estimated to be 75,000, with 4,000 sitting under cover, 22,000 standing under cover and 49,000 standing in the open. The capacity was set at 68,000 in 1938 and just under this number attended a fifth-round FA Cup tie against Everton in February 1939. Unlike now, the FA Cup was taken seriously in those days. During the First World War the ground was used as a rifle range for military training.

St Andrew's had a bad time in the Second World War. On the outbreak of hostilities it was closed on the orders of the Chief Constable, being the only ground in the country to be shut in this way, and it was only reopened after the matter was raised in Parliament. Subsequently the Railway End and the Kop were badly damaged by bombing, and then later, in a bizarre mishap, the Main Stand burned down. When damping down a brazier, a fireman mistook a bucket of petrol for a bucket of water.

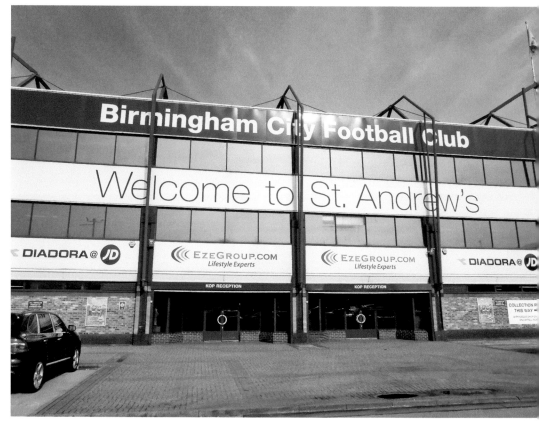

St Andrew's Stadium.

The stadium was rebuilt but by the 1980s it was in a bad way. There was a tragedy in 1985 when a boy was killed by a wall falling on him. It happened during a riot on the last day of the season. A six-year redevelopment plan was started in 1993 and it is now a pleasant all-weather stadium. The capacity is 30,016.

St Andrew's has been used for boxing as well as football. In 1949 Dick Turpin, who was mentioned in the Leamington chapter, beat Albert Finch on points to retain his British and Empire middleweight title. Turpin's brothers, Jack and future world champion Randolph, fought on the undercard. In 1965, after a postponement caused by rain, Henry Cooper beat local hero Johnny Prescott to retain his British and Commonwealth titles.

On the playing side, Birmingham City's record could be described as mixed. The best periods were the mid-1950s and early 1960s. The top season was 1955/56, when the club finished sixth in the first division and was the losing finalist in the FA Cup. They were finalists in the Inter-city Fairs Cup in both 1961 and 1962, and they beat local rivals Aston Villa to win the League Cup in 1963. Birmingham City was relegated in 1986 and it was then out of the top tier for sixteen seasons, two of them being spent in the third tier. Birmingham were ninth in the Premier League in 2009/10, but were relegated in 2010/11. However, in that season they did win the League Cup (then known as the Carling Cup) for a second time. At the time of writing, Birmingham City are in

the Championship (the second tier of English football) and occupy a position in the relegation zone. Their local rivals, Aston Villa, are also in the Championship and are pushing for promotion.

Birmingham City's most famous player was the goalkeeper Gil Merrick. He played 551 times for Birmingham and twenty-three times for England. His international games, which were all played while Birmingham was in the second division, included the 6-3 and 7-1 thrashings by Hungary. This led to him being dubbed 'Mister 13' because of the number of goals that he conceded in these two matches. This was unfair because Ferenc Puskas and the Magical Magyars were unstoppable and the whole team was outplayed. For ten years, and while playing for England, he worked four days a week as a schoolmaster. Can you imagine a current England footballer doing that? In 2009 Birmingham renamed the Railway Stand the Gil Merrick Stand in his honour.

Merrick retired from playing in 1960 and shortly afterwards took over as manager of the club. He had considerable success, but following a bad patch he was sacked in 1964. Merrick was very bitter and despite invitations from the club did not set foot in the ground for the next thirty-five years. He was finally reconciled shortly before his death.

Talk of Birmingham City Football Club is likely to trigger mention of Karen Brady (Baroness Brady). She was made managing director of the club in 1993 at the age of twenty-three. It was widely assumed that she got the job because she was the girlfriend of one of the owners, but this was not the case. The appointment attracted a lot of publicity, partly because of her gender and partly because of her age. It sounds apocryphal but the story goes that the first time that she sat on the team bus a player said: 'I can see your tits from here'. Brady replied: 'When I sell you to Crewe you won't be able to see them from there, will you?' The player was sold shortly afterwards. Brady is now involved with West Ham United and has had a successful career in business and other fields.

Journey's End: Moor Street Station, Birmingham, and Snow Hill Station, Birmingham

Moor Street and Snow Hill are two of the three main stations in the centre of Birmingham. The other is the much bigger New Street, which is served by trains from London Euston. This station and this line feature in my book *Great Railway Journeys: London to Birmingham by Rail*. Trains from London Marylebone go to Birmingham Moor Street and some finish there. Others go to Moor Street, then pass through a tunnel and finish at Snow Hill. For a time Moor Street was hardly used and at one time Snow Hill was demolished. However, there has been a renaissance for both of them and they have important roles in the railway network.

How short-sighted some of the politicians and leaders of yesteryear were when it came to the closure of lines and stations. We could have lost London Marylebone and we almost did lose London St Pancras. Where would we be without them, and St Pancras in particular? The number of railway journeys has greatly increased and we miss some of the facilities

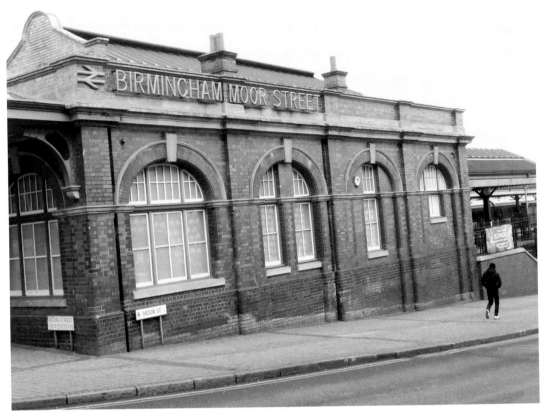

Moor Street Station.

that have gone. A small number have re-opened and there are plans to do the same with a few of the others. The line from Oxford to Cambridge is one example.

Moor Street was refurbished in the 2000s, and, as can be seen from the photograph, it is a brick building with a pleasant appearance. It was done in 1930s style and has reproduction lamps, clock, seating and signage. Gilt signage and the GWR badge appear on the outside brickwork.

Until 1909 Snow Hill was the Great Western station for central Birmingham. However, in the period leading up to this date the number of trains was increasing and it became clear that the twin-tracked Snow Hill Tunnel bringing in trains from the south would become unable to cope. It was therefore decided that an additional station should be built at the other end of the tunnel. This was Moor Street, which became the terminus for local trains. Originally there were just temporary buildings, but permanent ones were finished in 1914. The tracks into Snow Hill were adjacent and trains to that station did not stop at Moor Street.

A particularly interesting Moor Street feature was two electronically operated traversers located at the buffer end of the platforms. This was a space-saving measure that allowed the steam locomotives to move sideways between tracks, instead of having to reverse through crossovers. They were removed in 1967 when all the services to the station switched to diesel multiple unit operation and they were no longer needed.

In 1968 the line between Moor Street and Snow Hill was closed down and plans were made to terminate Moor Street Station. However, this caused much protest and five local authorities took their objections to the High Court. They won and the station was reprieved. From 1968 until the mid-1970s it was at a very low ebb and the usage was minimal. Furthermore, a large goods station, which had been opened adjacent to the passenger station in 1914, was closed. This was done in 1972.

Snow Hill has a much longer history than Moor Street. It was built by the Great Western Railway and opened in 1852. It was on the line from London Paddington to Wolverhampton and Birkenhead. Its original name was just Birmingham, but in rapid succession this was changed to Great Charles Street, Livery Street and then, in 1858, to Snow Hill.

The nearby Great Western Hotel was opened in 1863, but this only lasted for a few years. It was not intended that Snow Hill should remain as the Great Western's main station in Birmingham, but politics prevented the line reaching Curzon Street, which was the terminus of the line from Euston.

The original Snow Hill Station could hardly have been more basic, being just a wooden shed covering the platforms. This was presumably because of the expectation that the line would be extended to Curzon Street. The station was improved in 1871, and it then comprised two through platforms with bay platforms at the northern end. The structure

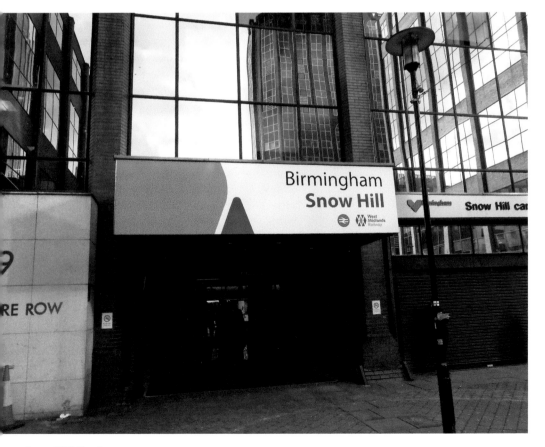

Snow Hill Station.

was covered by an arched roof. Trains from the south arrived through the Snow Hill Tunnel, which was built by the cut and cover method.

The line prospered and traffic increased. This resulted in a major expansion and rebuild between 1906 and 1912. Snow Hill then consisted of two large island platforms, containing four through platforms and four bay platforms for terminating trains at the northern end. The through platforms were long enough to accommodate two trains at a time. Scissor crossings allowed trains to pass in front of or behind other trains, which effectively created a ten-platform station. The building was of a high standard. There was a large booking hall with an arched glass roof, and the waiting rooms were attractive, featuring oak beams.

After 1912 trains ran in many directions. The services to and from London Paddington went to and from Snow Hill, but in 1967 they were switched to New Street. After a while this service was discontinued, though of course New Street sent trains to London Euston and received trains from there.

Until the mid-1960s Snow Hill was a major station. At that time it handled 7.5 million passengers annually, compared with 10.2 million handled by New Street. However, in 1966 it was decided that Snow Hill should close as soon as the electrification of the West Coast Main Line was complete. This was substantially done by 1968 and completely done by 1972. The building was demolished and the site was used as a car park.

The new Snow Hill Station opened in 1987 and provided services to the south. The Snow Hill Tunnel reopened at the same time and in 1993 limited services to London Marylebone commenced. A second phase for other services was completed in 1995.

The new station is smaller than the one that it replaced, and for me at least is not pleasing to the eye. 'Functional' is a good word to describe it. A multi-storey car park stands over the main platform area, which means that the platforms must perpetually be lit with artificial light. There are two island platforms, giving four platform faces.